SECRET GARDENS

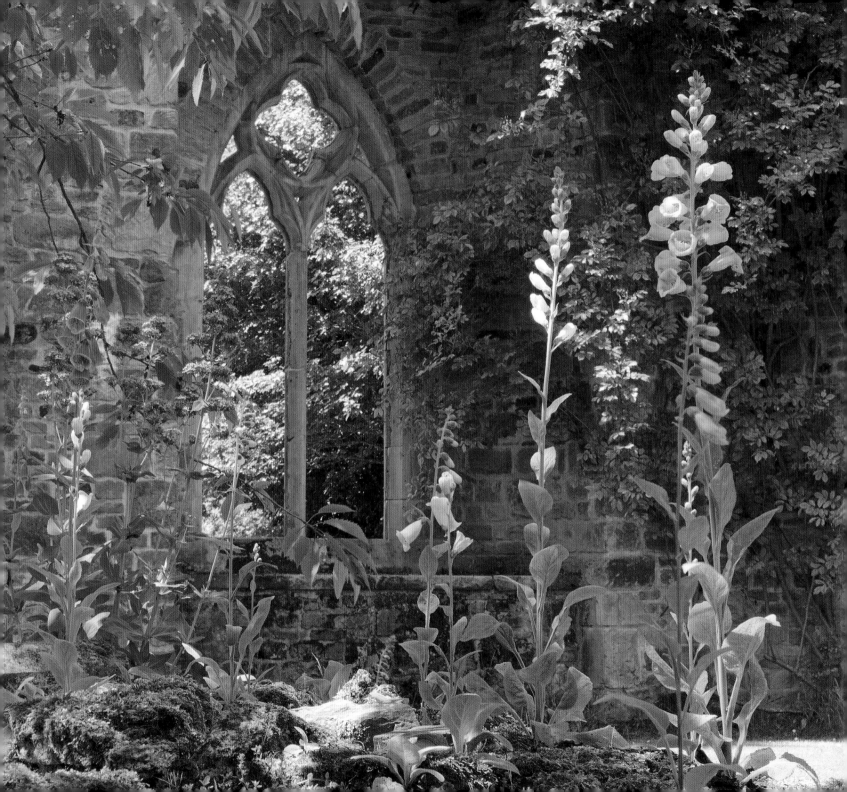

SECRET GARDENS

CLAIRE MASSET

National Trust

First published in the United Kingdom in 2017 by National Trust Books
1 Gower Street
London WC1E 6HD

An imprint of Pavilion Books Group

ISBN: 9781909881907

A CIP catalogue record for this book is available from the British Library.

10 9 8 7 6 5 4 3 2 1

Reproduction by Colourdepth, UK
Printed by 1010 Printing International Ltd, China

This book can be ordered direct from the publisher at the website:
www.pavilionbooks.com, or try your local bookshop.

Also available at National Trust shops or www.shop.nationaltrust.org.uk.

FRONT COVER Wisteria in flower at Trelissick Garden, Cornwall.
PAGE TWO Foxgloves and red valerian in the ruined abbey folly at Woolbeding
Gardens, Sussex.

Contents

INTRODUCTION

Most gardens are secret, shared only by friends and family. Those of you who have your own plot will know that a garden is an extension of the home, set apart from the commotions and stresses of the outside world. My own garden is a place of nourishment – both spiritual and creative – and escape.

Over the years I've realised that visiting gardens can provide this same sense of getting away from it all. For me the best gardens are those that give you that delicious illusion of discovering a place as if you were the first to do so. Like Mary Lennox in Frances Hodgson Burnett's wonderful book *The Secret Garden*, I love the thrill of finding a beautiful and secluded place. I bask in its quietness and beauty, feeling, if only for a few minutes, as though it's mine.

It's this desire for surprise and solitude that drives me to lesser-known gardens. Within them are many delights, from unexpected sights and quiet corners to horticultural inspiration and questions waiting to be answered. How, for instance, was Overbeck's – an exotic garden where cacti grow unprotected – ever created on such a rugged and precipitous stretch of the Devon coast? Who were these intrepid sisters who created, at Plas yn Rhiw, a lush paradise on one of the most wind-battered and remote headlands in North Wales? And why is such a varied and larger-than-most town garden hidden behind a Georgian terrace in Wisbech?

A secluded corner at Monk's House, Virginia Woolf's country home and retreat in East Sussex.

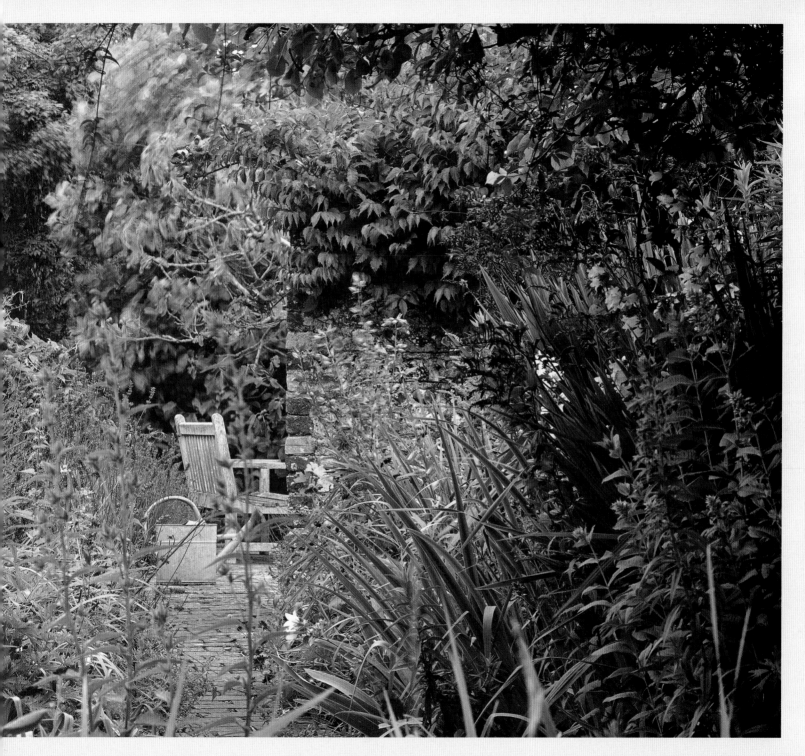

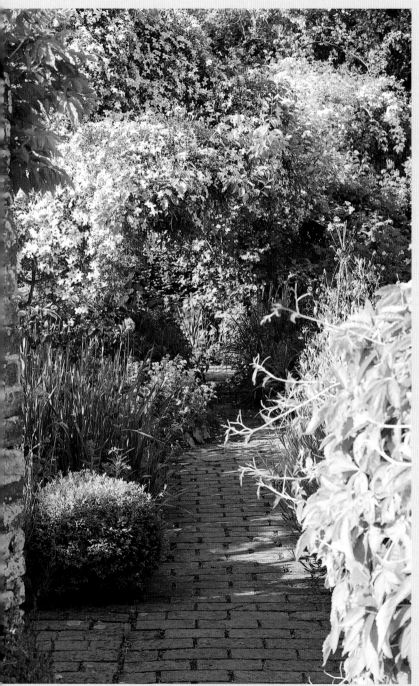

FAR LEFT Clematis and irises in spring at Monk's House, East Sussex.

LEFT Late summer in the orchard at Fenton House, London.

LEFT BOTTOM The Pool Room at Woolbeding Gardens, Sussex, in late summer.

BELOW Peckover House in Cambridgeshire, which is famous for its roses.

RIGHT A rambling rose clings to the stone walls at Plas yn Rhiw, Gwynedd.

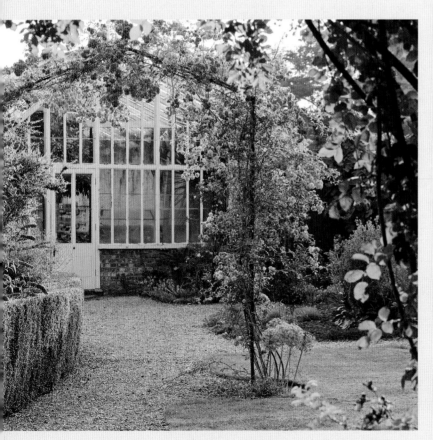

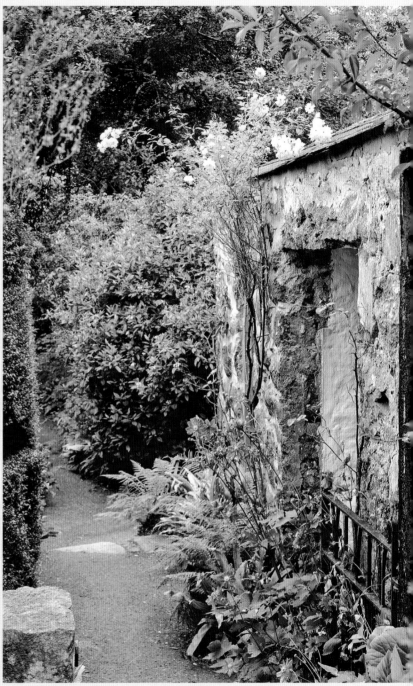

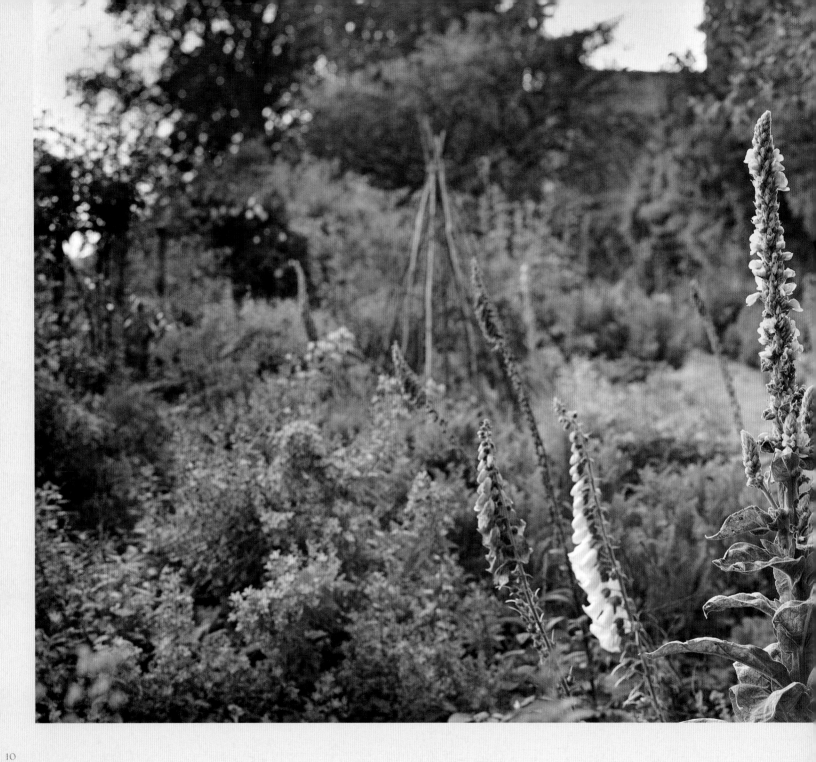

Secret gardens have another draw, too. Because of their relatively small size, I find myself connecting with their creators more closely than I do in the more public domain of a grand mansion. These are intimate gardens, not large showpieces designed for self-promotion. By their very nature, they are personal creations. It sometimes feels as though you are visiting the garden of a friend, even if its creator is world-famous or long gone.

'So this is where Virginia Woolf lived and worked, wrote and was inspired,' I thought, overwhelmed, when I pushed the little wooden gate to Monk's House and first set eyes on her garden. Here in the depths of rural Sussex is where she plotted, and agonised over, many of her novels. But here too is where she dug, weeded, picked pears and apples, and took part in a multitude of gardening tasks, ably assisting her husband Leonard in creating this enchanting place.

Beyond the personal stories, secret gardens are sources of simple and profound pleasures. They take us back to our carefree childhood years. Children love gardens because they represent freedom, discovery and surprise. In these secluded and safe spots they can hide, make dens and create a world of make-believe. Secret gardens are places of wonder and magic for children and adults alike. Here are some of my favourites. I hope you enjoy discovering them as much as I have.

The cottage-style garden at Hill Top, Betrix Potter's small farmhouse in Cumbria.

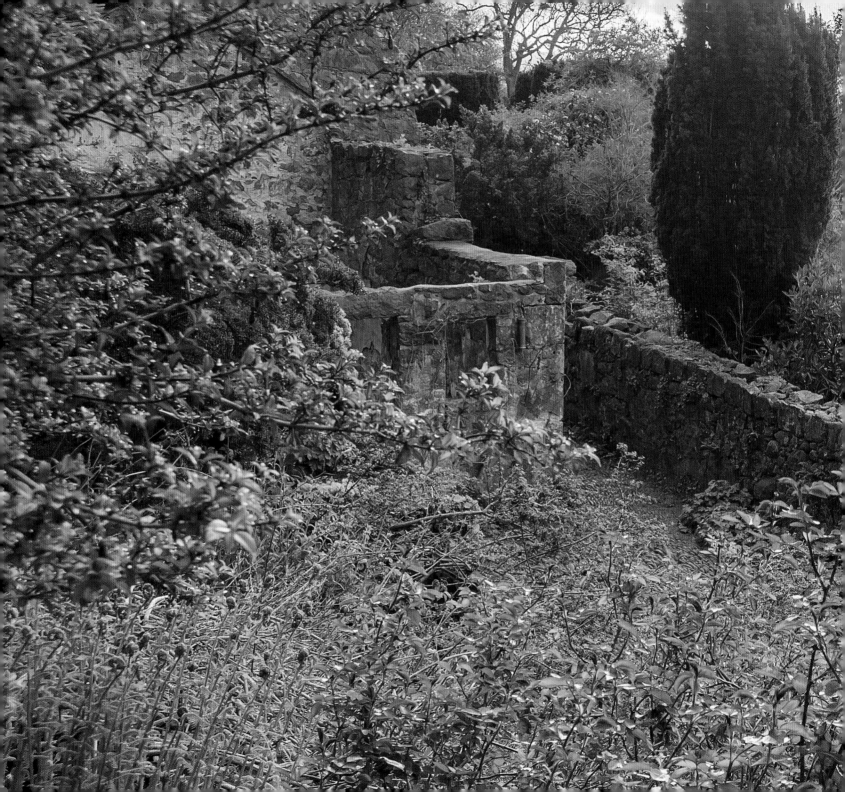

GARDENS ON THE EDGE OF THE WORLD

PLAS YN RHIW, GWYNEDD

'To those sailing bleakly across Hell's Mouth, there is just one spot where the eye may gratefully rest on relative snugness,' wrote the architect Clough Williams-Ellis. This favoured place is Plas yn Rhiw. Set halfway down a hillside and facing south-east, its small manor house, garden and woodland lie in sheltered seclusion, protected from the strong south-westerlies by the ragged tor of Mynydd y Graig. While the rest of the Llŷn Peninsula is crushed by gales, the garden is like a heated greenhouse in winter. Here the flowers bloom all year round.

The house and garden look the way they do today thanks to three indomitable sisters: Eileen, Lorna and Honora Keating. They fell in love with the area when they started holidaying on the peninsula with their mother in 1919. During their first visit here, they came across Plas yn Rhiw. Uninhabited and unloved, it was already in a state of abandoned neglect, and thus it remained for almost 20 years until the sisters, none of them married, bought it for themselves and their mother in 1938.

When Clough Williams-Ellis saw the garden, he described it as 'a jungle of fuchsias, figs and azaleas'. The house was no better. The front door was so overgrown with brambles that you had to climb through a side window to get in. Dry rot had taken over and a stream ran through the building. Undeterred, the sisters started restoring their new acquisition and, with the help of Williams-Ellis, within a year the house was made habitable.

The sisters, whose father had been an architect, must have appreciated their new home's simple beauty. Behind the elegant Victorian veranda and Georgian sash-windows lay a solid seventeenth-century building. Over the years, Eileen, Lorna and Honora filled it with possessions: fur coats, fashionable shoes, elegant Georgian chairs, the family gramophone and watercolours by Honora, items that speak of comfortable and cosy lives.

PREVIOUS PAGE Dawn breaks over the sea, as the garden at Plas yn Rhiw offers glimpses of the Merioneth Mountains beyond.

RIGHT Looking up towards the house, you can see the network of box 'walls' in the parterre garden, which was uncovered by the Keating sisters when they started creating their garden.

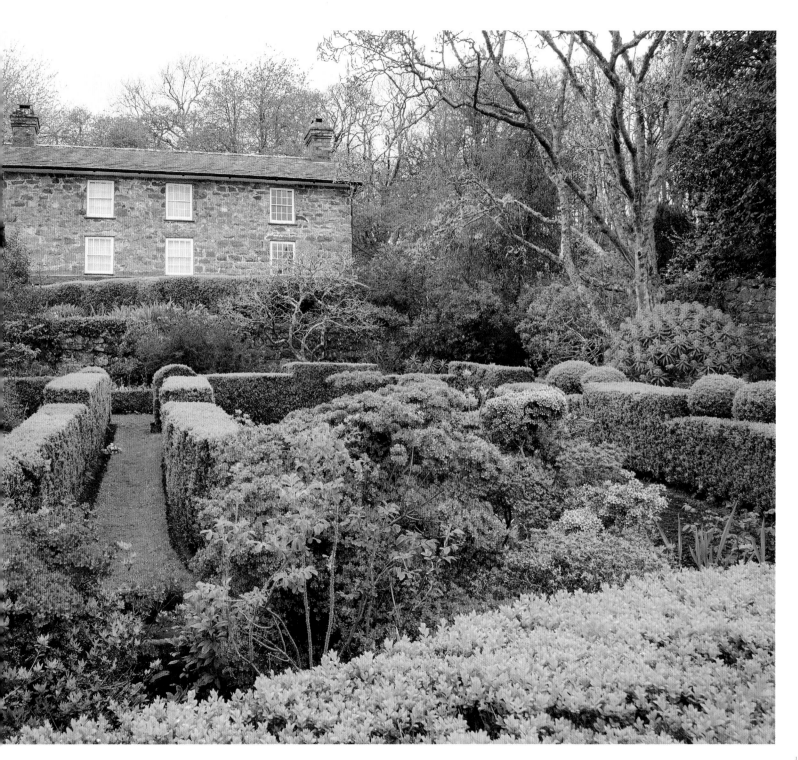

And yet this was no privileged existence. Like Beatrix Potter in the Lake District, the sisters devoted the last decades of their lives to protecting the natural beauty of the area, waging campaigns against commercial forestry, caravan parks and proposals for the construction of a nuclear power station. Like Potter, they developed a productive partnership with the National Trust, acquiring land with the sole purpose of donating it to the charity. They gifted Plas yn Rhiw and its 23 hectares (58 acres) to the Trust in 1952 and, while they continued to live here until Lorna Keating died in 1981, the sisters delighted in giving tours of their house and garden. After plying visitors with afternoon tea, they would invite them to join the National Trust. It worked a treat. Over the years they acquired over 330 acres of land, all of which they gave to the Trust.

Honora, the youngest of the sisters, was the driving force behind the garden's restoration. Trained at the Slade School of Art, she was both artistically gifted and a keen plantswoman. What a delight it must have been to discover, under the brambles, bracken and weeds, a network of box-lined paths and the remains of a box parterre below the house. Here, Sleeping Beauty-like, lay the structure that she would use to create the garden.

Honora and her sisters were passionate conservationists and in their gardening they displayed a respect for nature, rather than a desire to control it. Apart from the clipped box, nature was hardly ever constricted or tamed. Old walls – such as those of the roofless stables – provided the ideal backdrop on which to grow

Ivy and ferns have been left to smother the small wall adjoining these weathered steps, creating a magical, almost other-worldly feel.

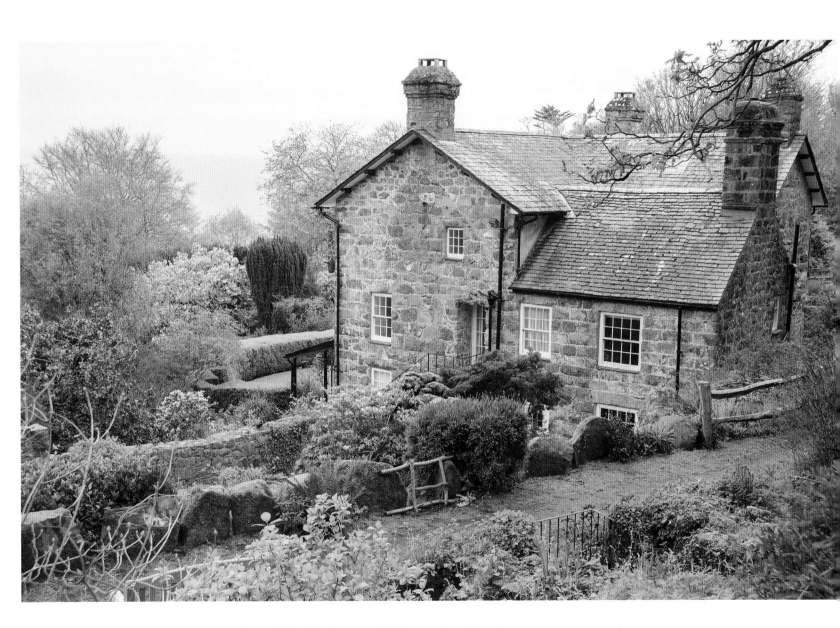

The soft grey granite of the house is an elegant foil for the lush greens and bright magentas of the spring season.

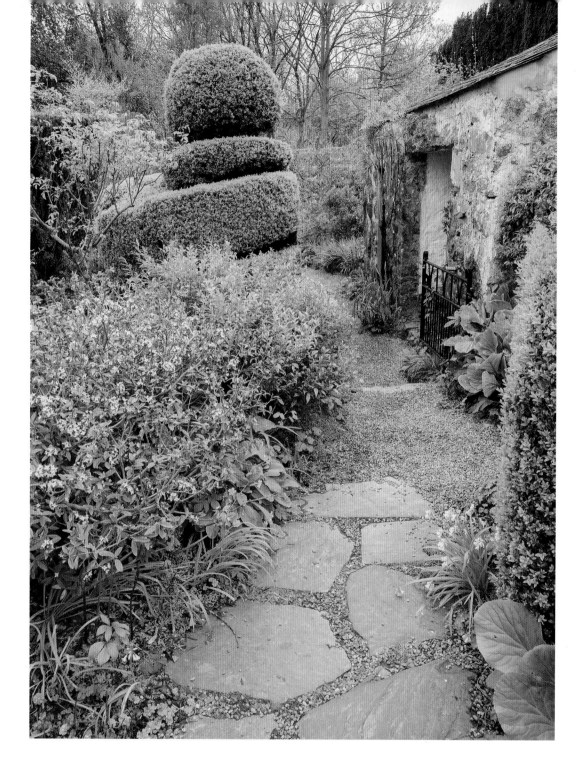

Narrow paths and passageways lead you from one small space to another, as you twist and turn, brushing against one plant after another.

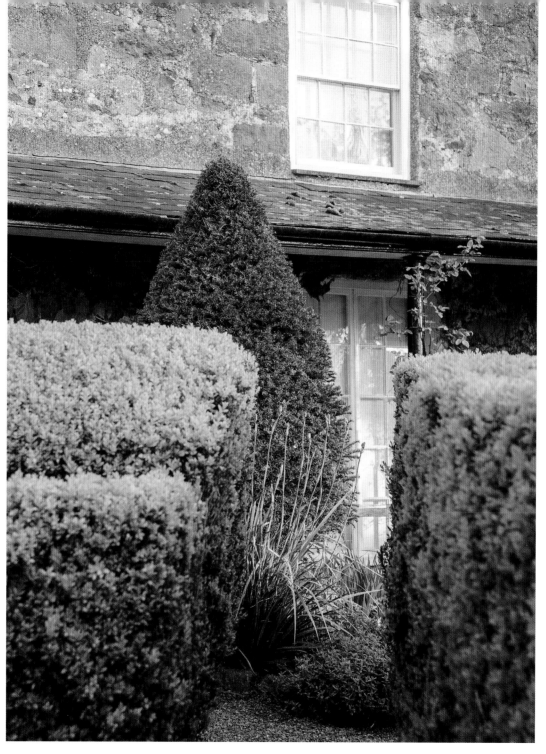

Looking through the network of box hedges towards a neatly clipped yew, the eye is drawn to the Victorian veranda, home to some of the garden's most tender plants. At times the scene here looks almost Mediterranean.

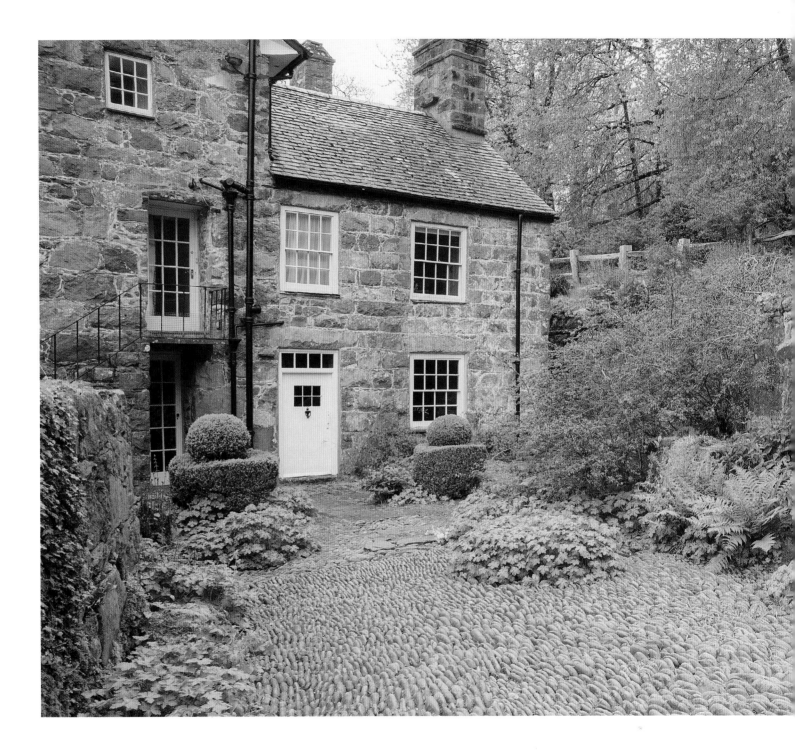

LEFT In the courtyard near the house, plants such as ferns and hardy geraniums colonise the cobbles and old walls.

BELOW Hart's tongue fern nestles amongst the cobbles in the courtyard.

roses. Along the paved and cobbled paths, plants such as hardy geraniums and ferns grew wherever they could, while moss and lichen clothed the garden in a veil of timeless beauty.

With its narrow pathways, its twists and turns, its small compartments and generous planting, it would be easy to think of this small one-acre garden as inward looking. Yet your eye is constantly being pulled towards the magnificent views of the sea beyond, in a delicious to-and-fro that offers the perfect balance of comforting intimacy and sublime grandeur.

Such harmonious tension can also be felt in the planting. Native wildflowers, ferns, hardy cottage garden plants and shrubs of sweet bay and cherry laurel happily coexist with more exotic beauties. Honora could not resist adding tender plants to her garden and so rare and hybrid magnolias, camellias and rhododendrons offer a magical show throughout spring, including a magnificent *Magnolia campbellii* subsp. *mollicomata* with large, goblet-shaped pink flowers. Planted in 1947 by the sisters, it was a gift from that other wonderful Welsh garden, Bodnant, near Colwyn Bay. In August and September it is smothered in stunning crimson seed-pods.

The veranda, the most sheltered area of the garden, is the ideal spot for *Rosa* 'Zéphirine Drouhin' and the tender *Abutilon* 'Ashford Red', which flowers almost continuously. Elsewhere, eucryphias provide a show of white from summer through to autumn, while a fine collection of scented plants including viburnums, daphnes and jasmines add an extra dimension to the experience. Some of these, such as *Oemleria cerasiformis* with fragrant greenish-white blooms, flower during the late winter months, when the first snowdrops are just appearing.

In keeping with the sisters' love of nature, the garden is managed organically and is now, as it was in their day, both beautiful and productive. Their small vegetable garden has been reinstated and, above the house, a new orchard, filled with native Welsh fruit trees and a mass of wildflowers in the spring, is slowly maturing.

Simple yet sophisticated, Plas yn Rhiw is a garden for all seasons. For the garden lover there is no sweeter joy than waking up in the little holiday cottage next to the sisters' house, after a night of lashing rain, to the sun rising above the sea as it warms the lawns.

ABOVE Japanese anemones add colour and grace to the garden from late summer to early autumn.

RIGHT The purple *Rhododendron* 'Praecox' with Knap Hill and Japanese azaleas are some of Plas yn Rhiw's spring highlights.

OVERBECK'S, DEVON

To reach Overbeck's you have to negotiate hairpin bends and narrow roads, but when you arrive you are rewarded with of one the most dramatic gardens in the British Isles. Its position – perched on a steep cliff with superb views of Salcombe estuary – is stunning, but the plant collection is even more astonishing.

The 3-hectare (7-acre) site brims with all manner of exotic and tender plants. Palms, salvias and olive trees rub shoulders with bananas, agaves, acacias and even cacti growing out in the open. There are leaves in all their varied glory, from the dangerously spiky to the smallest you've ever seen, plants that look more like sculptures than living things, and strangely shaped flowers in the boldest shades of blue, red and orange.

Since the late nineteenth century, this spirit of experimentation has been alive at Overbeck's. In 1892, an adventurous builder erected a small house here, but it was in 1901 that things really took off. Edric Hopkins, an avid gardener, bought Sharpitor (as it was then known, after Sharp Tor, a craggy outcrop nearby) along with a couple of acres of land. The large amount of landscaping dates from then. Today it is hard to imagine just how much earth was moved to create a site fit for a garden. Massive retaining walls were built to introduce areas of level ground, using the attractive grey rock, known as mica-schist, quarried on site.

Hopkins made the most of the mild climate, the shelter of the woodland and the free-draining soil – ideal growing conditions for Mediterranean and sub-tropical plants. He lived here until 1913 when Sharpitor was sold to Captain George Medlicott Vereker, another passionate gardener. The Verekers built a bigger house on the same plot and further developed the garden. In 1928 yet another plantsman took over – chemist Otto Overbeck, who bought Sharpitor for his retirement and lived here until his death in 1937, when he left it to the National Trust.

Otto Overbeck owed his wealth to a strange invention, the rejuvenator, which he claimed could defy the ageing process. Of course the contraption didn't work, but he grew rich from it and was able to indulge his passion for plants. He collected avidly, particularly acacias, eucalyptus, fuchsias, succulents, cacti and palms and, since his

The rich blue of the sea is the perfect backdrop for the varying shapes of trees and shrubs at Overbeck's.

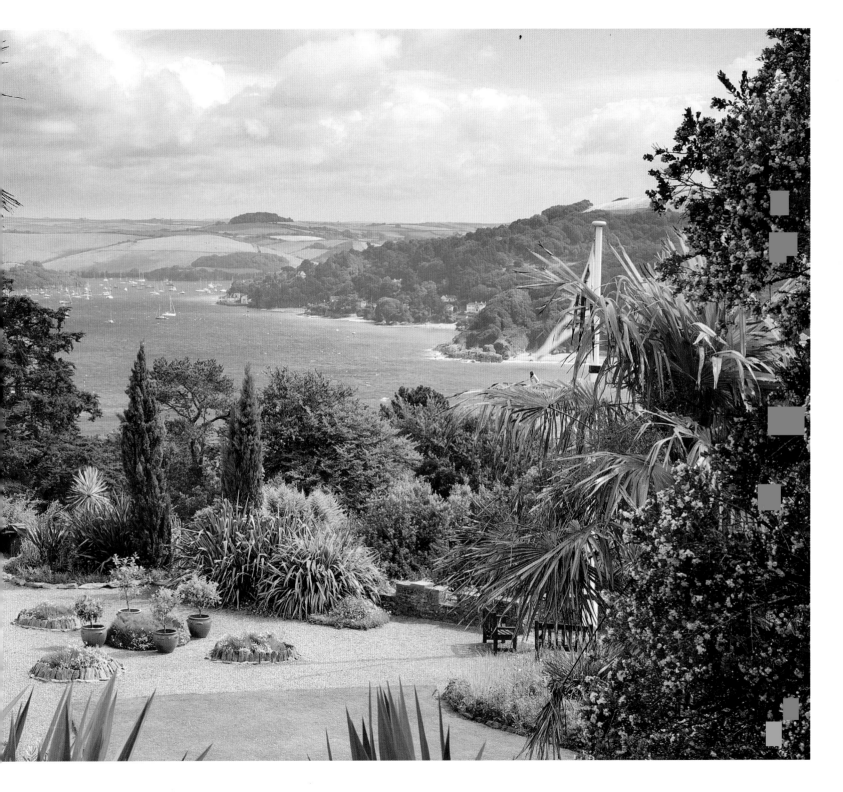

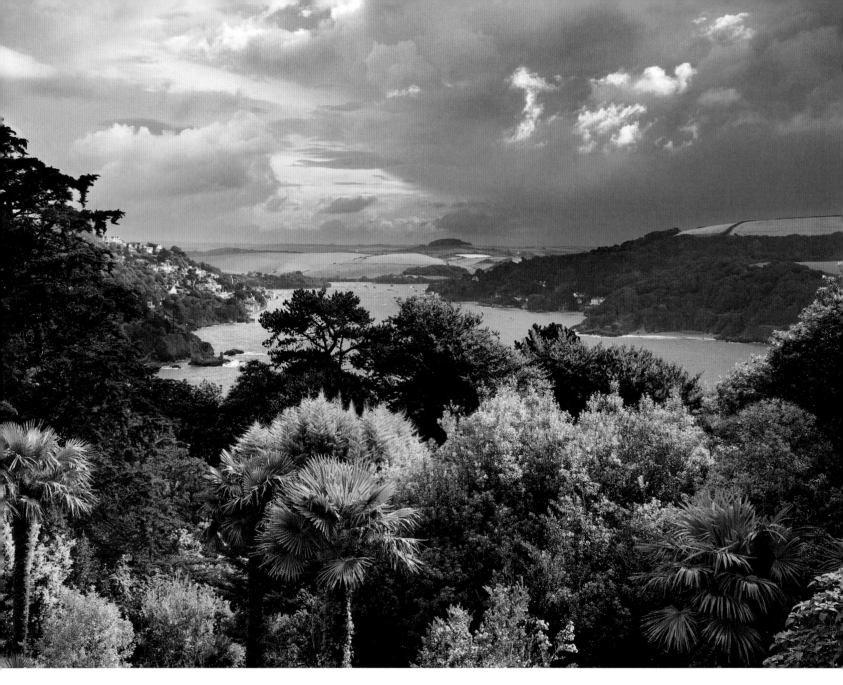

ABOVE The dramatic view from the top of the garden towards Salcombe estuary. TOP RIGHT With its purple, almost black leaves, *Aeonium arboreum* 'Schwarzkopf' is a particularly striking succulent. The sunnier it is, the darker its colour. BOTTOM RIGHT *Echeveria glauca* produces bell-shaped pink flowers in the summer, which contrast beautifully with its grey-green leaves.

bequest, the Trust has developed the garden in the same spirit. 'The garden is lively and anarchic. I like to describe it as the triumph of the determined amateur,' explains head gardener Catrina Saunders. 'This is gardening on the edge. Every year we push hardiness zones and try out new plants. I want people to come in and almost fall over in shock.' With its many discrete areas, the garden gives away its charms slowly – but what charms! Each and every corner brings a 'Wow!' rather than a whisper of 'Isn't this lovely?' Exploring the garden is an adventure in itself.

Anticipation is already there as you enter the garden through the Spanish-inspired gates and descend the palm-lined steps. The estuary comes into full view and your initial impression of exoticism is confirmed; yet more palms, along with watsonias and aloes, greet you.

In the bank by the house are what look like clipped box balls – these are actually myrtles (*Luma apiculata*). Clearly, Overbeck's defies gardening expectations. Even in the Statue Garden – a formal area with rectangular beds set in a perfect lawn – the planting is far from traditional. These are not your typical blowsy borders with mellow roses, lavender and the like. Instead, from July to October, it's a joyful riot of colourful cannas, kniphofias, salvias and crocosmias.

In Rock Dell, the old quarry showing the original rock face, it's all about leaves: spear-shaped in the case of the phormiums, yuccas, astelias and cordylines, massive and deeply cut in the case of *Tetrapanax papyrifer* 'Rex'. Dark tones are introduced with the purple, near-black foliage of *Aeonium arboreum* 'Schwarzkopf' and *Pittosporum tenuifolium* 'Tom Thumb'. From here, steps take you to the topmost part of the garden, where an olive grove comes into sight; on a sunny day, with the azure sea before you, you could easily be in Sicily.

The enclosed Banana Garden is reminiscent of even warmer climes. Bananas (*Musa basjoo* and *Musa sikkimensis*) have grown here since Edric Hopkins's time, but there are other treasures too, such as the rare and hard-to-grow *Hedychium greenii*, a red-flowered ginger from Nepal, and two exquisite acacias: *Acacia verticillata*, with needle-like leaves and soft-yellow flowers; and *Acacia pravissima*, which in early spring is covered in small, puffy, bright yellow flowers. Here also is the hundred-year-old *Magnolia campbellii* 'Overbecks'. The garden's very own cultivar, it is different from its parent tree in having a large, more intense pink bloom. It fell during a storm in 1999, but its new recumbent self is now flourishing.

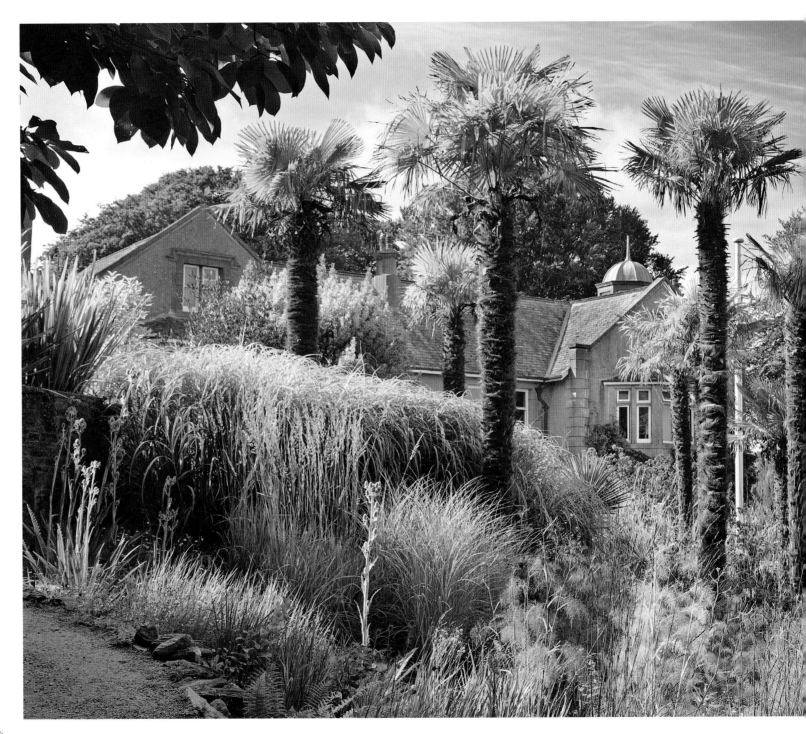

Palm Bank – the garden's main artery – is punctuated with proud-looking palms, of which there are eight different varieties in the garden. Otto Overbeck planted many of the Chusan palms (*Trachycarpus fortunei*) in the 1920s. They now self-seed so prolifically that the gardeners at Overbeck's have to keep a watchful eye for seedlings. The bank's poor free-draining soil is ideal for restios, grasses whose graceful foliage add movement amongst the static succulents. Here too are show-stoppers. Large and sculptural, *Agave mitis var. mitis* is tipped with large spines that Native Americans used for sewing leather moccasins. *Colletia cruciata* has spiky, greeny-blue stems that look like aeroplane wings. 'Butterflies love its little white flowers,' says Catrina Saunders. 'But how they manage to negotiate the spikes I don't know!' *Juania australis* is the original Robinson Crusoe plant, native only of the Juan Fernandez Islands, west of Chile, and almost extinct in the wild.

With so many extraordinary plants originating from the Mediterranean, Africa, the Far East, New Zealand and South America, Overbeck's is worth exploring slowly. Every turn brings a discovery, a rare beauty you've never set eyes on before. And each area has its own atmosphere and mini microclimate. The whole experience makes you reassess what gardening is all about, and perhaps wish for a very different garden of your own.

Palms are underplanted with different types of restios, rush-like grasses that thrive in the poor and free-draining soil.

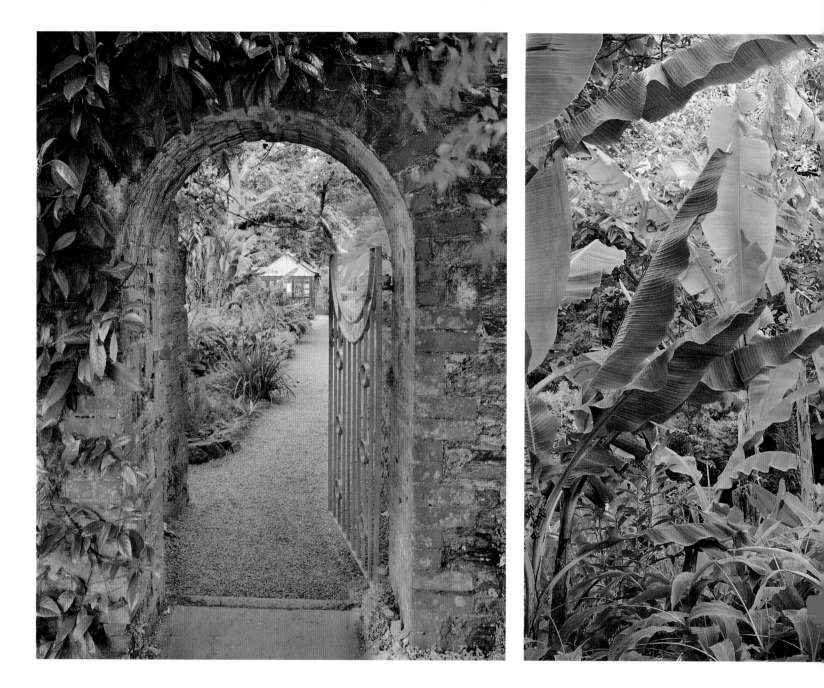

Looking towards the Banana Garden with its bright blue greenhouse in the distance – a fitting colour for such an exotic garden.

Lush foliage and dense planting create a jungle atmosphere in the Banana Garden.

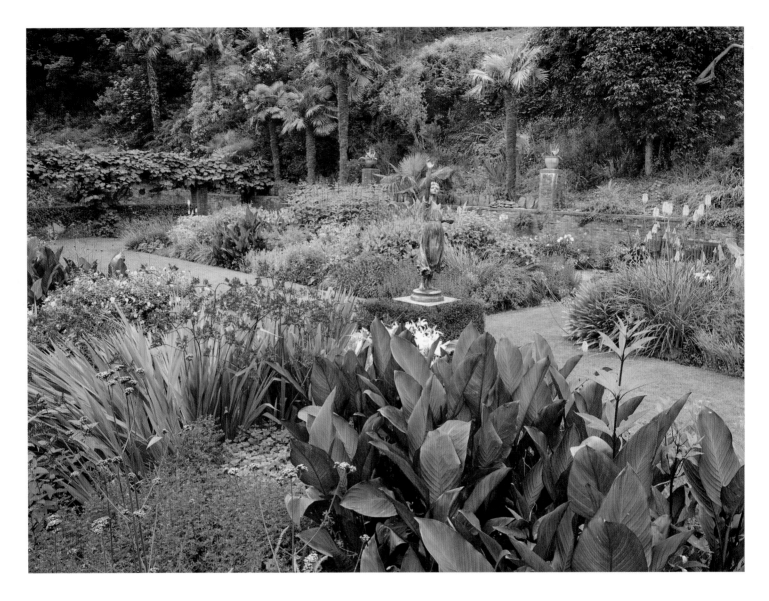

In late summer the Statue Garden displays a vibrant show of crocosmias, kniphofias, agapanthus and cannas.

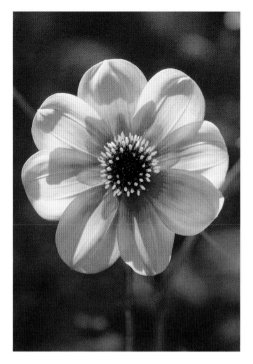

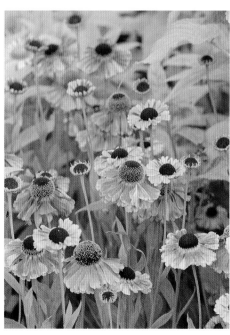

TOP LEFT *Dahlia* 'Moonfire' flowering in the Statue Garden in late summer.

ABOVE *Verbena bonariensis* and the fiery red *Crocosmia* 'Lucifer' in the Statue Garden in July.

FAR LEFT *Musa basjoo*, known as the Japanese banana, bears large and dramatic flowers, usually in late summer.

LEFT The showy, daisy-like blooms of *Helenium* 'Sahin's Early Flowering' appear in early summer and last until the autumn.

BODYSGALLEN, CLWYD

Every year thousands of visitors make the pilgrimage to the famous garden at Bodnant in North Wales, but few realise that not far away is another horticultural masterpiece. It might be more compact and less showy, but Bodysgallen is exquisite. In this remote and atmospheric site, garden lovers will discover a pleasing mix of walks, terraces and enclosures, an attractive kitchen garden, and a wooded landscape with glorious views of Conwy Castle and Snowdonia.

Bodysgallen Hall is one of the three Historic House Hotels of the National Trust. As such the garden is only open to hotel patrons, but it is well worth the cost of an afternoon tea. Both the house and grounds have a charming Arts and Crafts feel and, indeed, Bodysgallen enjoyed its heyday in the early 1900s. William Morris would have appreciated the sensitive mingling of architectural features, such as ancient walls and steps, with clipped evergreens and neat beds of roses, shrubs and old-fashioned perennials.

Despite the strong Arts and Crafts layer, this is an historic spot. In the thirteenth century a watchtower was built on a rocky outcrop to overlook Conwy Castle. The network of terraces and compartments to the south-east of the house probably date from the sixteenth century when the Wynn family was in residence. Today, viewed from the woodland, Bodysgallen appears a diminutive castle protecting its bijou estate.

With its walks and low box hedges delineating compartments, the garden feels like an extension of the house and, like all good gardens, it invites you to wander. The owner of Bodysgallen in the late nineteenth century was Lady Augusta Mostyn, daughter of the 4th Earl of Abergavenny. Widowed at the age of 31, she took over the management of the estate for her sons and dedicated her life to good causes. Artistically gifted and pioneering, she was the founder of the Mostyn Art Gallery in Llandudno, the first art gallery dedicated to women artists.

The neatly clipped domes of the ornamental silver pear, *Pyrus salisifolia*, punctuate the view from the walled rose garden.

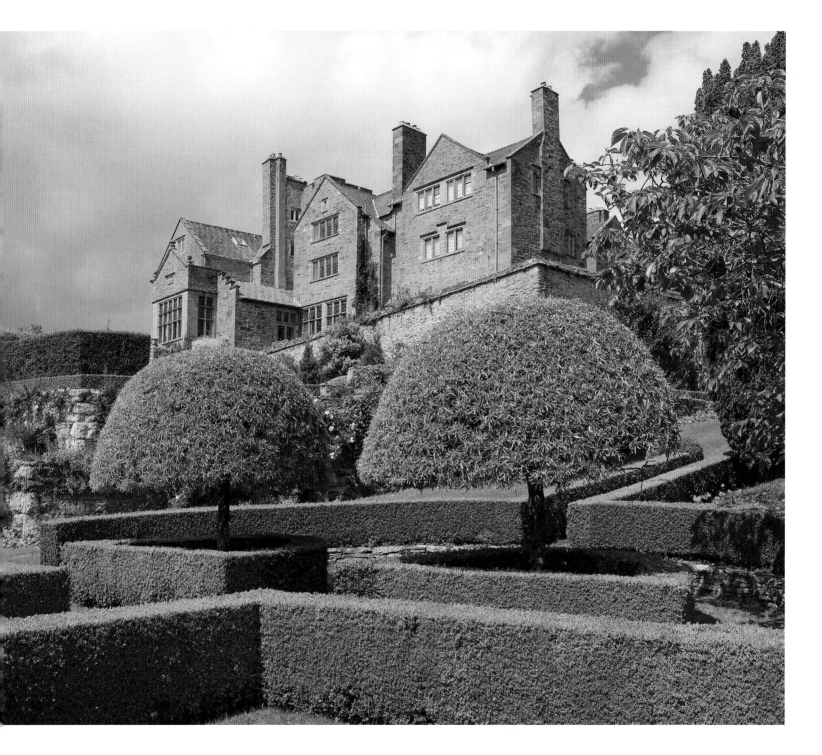

TOP On a clear day you can see Snowdonia from the entrance to Bodysgallen Hall. ABOVE The woodland walk takes you beyond the confines of the formal areas to the wilder parts of the garden, culminating in a long terrace where views of Snowdonia are suddenly revealed.

Red valerian (*Centranthus ruber*) has colonised many of the walls in the garden, creating a long-lasting show of bee- and butterfly-attracting blooms from late spring to autumn.

Before the 1880s, the garden focused predominantly on the production of fruit and vegetables for the house, but Lady Mostyn changed all that. In 1884, she turned the large orchard into a formal rose garden as a wedding gift for her son. The orchard, meanwhile, was replanted at Galchog, the head gardener's home a quarter of a mile away. On one of the top terraces – the site of a large cold frame – she created a rectangular lily pond, a typical Arts and Crafts feature. Perhaps her most striking achievement was to reinstate an ancient, possibly Jacobean, herb-filled parterre, inspired by an earlier design, the source of which remains a mystery.

Today's visitors can enjoy this jewel-like creation thanks to the work of head gardener Robert Owen, who since the 1980s has slowly been resurrecting the garden. In 1983, he replanted the parterre with a pattern of herbs – lavender, rosemary, thyme, sage, santolina and hyssop – all of which would have been available in Jacobean times. On a hot summer's day, their heady scent becomes trapped within the ancient walls, which are rippled with white and red valerian (*Centranthus ruber*).

The aim of the restoration has been to emulate the 1900s feeling throughout the garden, without disregarding the accretions of history. Early twentieth-century paths have been reinstated. White 'Iceberg' and 'Silver Anniversary' roses now grow in the island beds of the rose garden, where medlar, plum and damson trees also thrive – a nod to this area's earlier incarnation as an orchard. The borders on the edges are filled with lush, colourful plantings of irises, peonies, gladioli, dahlias, hollyhocks, and more roses.

The years following the First World War saw a huge reduction in the number of gardening staff on large and medium-sized estates. At Bodysgallen the team went from 14 to 5, so the decision was made to reduce the scale of the garden. Today, it is now restored to its original size; the previously neglected area returned to its former design, with espaliered pears and bush apple trees as the main crops.

Fruit production reaches its abundant height in the immaculate kitchen garden. Berry fruits are a speciality – from raspberries, redcurrants, gooseberries and blackberries

Ancient walls frame the view from the parterre to the walled rose garden.

RIGHT While the rectangular lily pond in the foreground is cornered with balls of box, the walled rose garden (middle and background) features straight intersecting paths and neat beds of white roses: formality in all its precise beauty.

FAR RIGHT Bodysgallen's unusual wheel-shaped parterre is its most striking feature and yet all the plants – herbs and box – are restricted to shades of green and grey. The borders surrounding the parterre are a mixture of shrubs and perennials, adding colour during the spring and summer months.

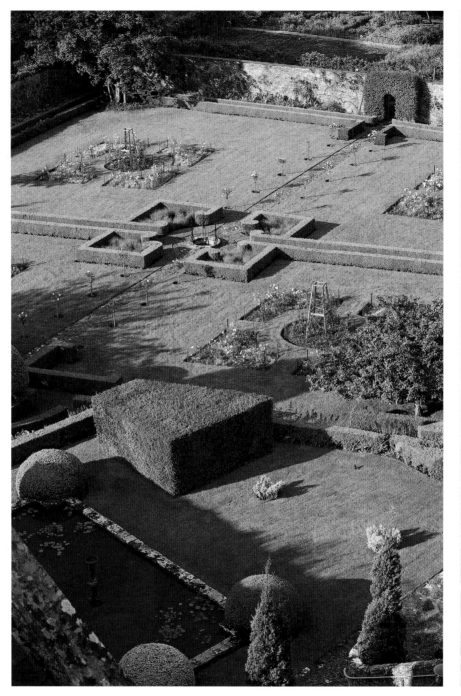

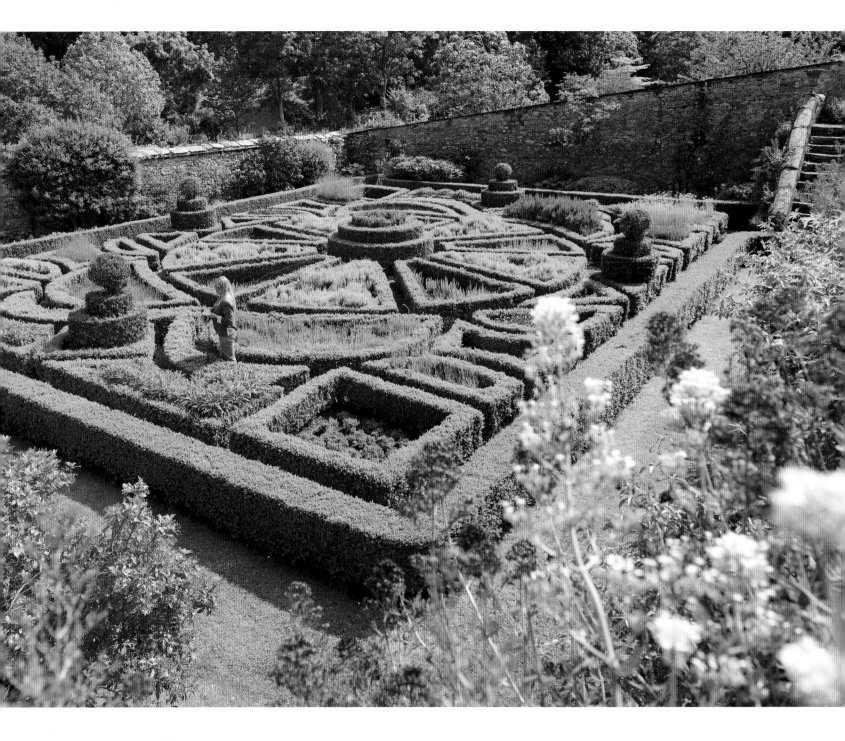

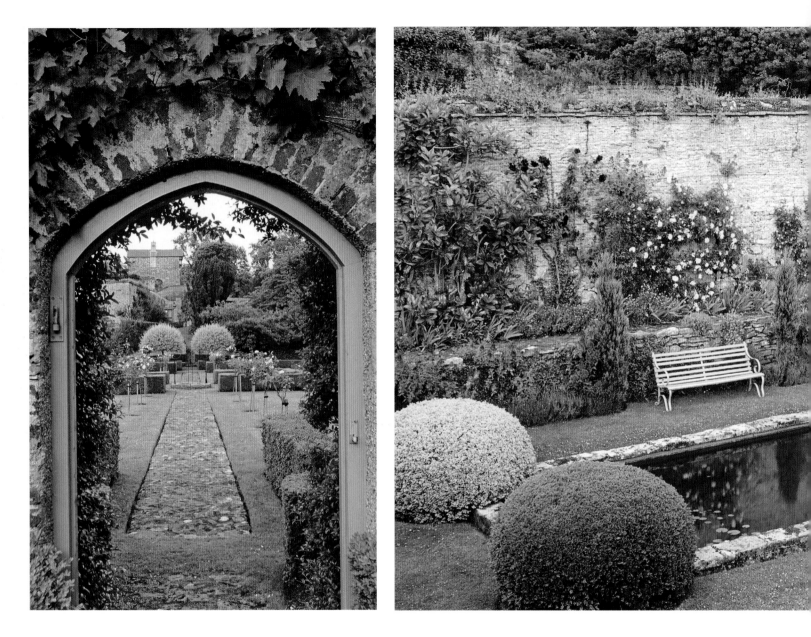

The view through the arched doorway to the rose garden with its domed silver pears and standard roses.

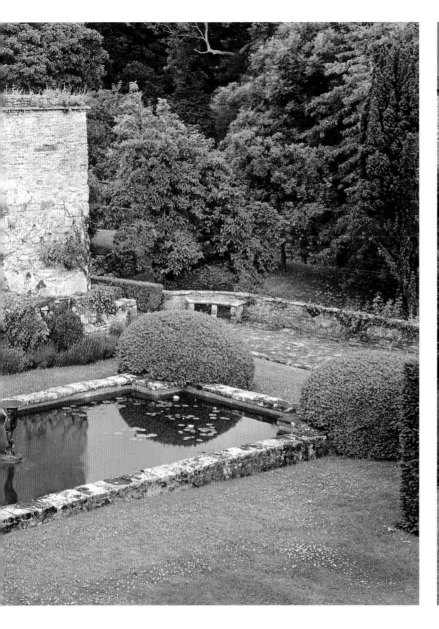

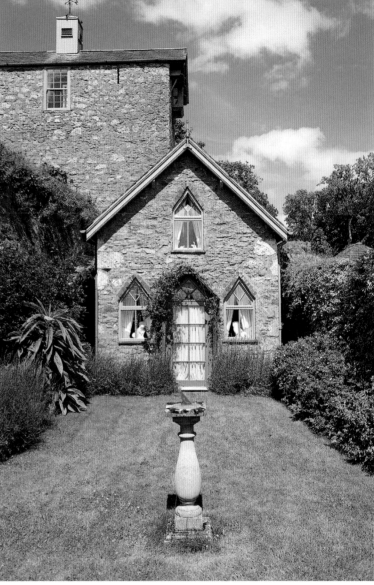

The lily pond features box balls on each corner. This traditional Arts and Crafts device creates a harmonious focal point within a garden room.

Windows, door and roof are in perfect triangular harmony in the tiny Gingerbread House adjacent to the Hall.

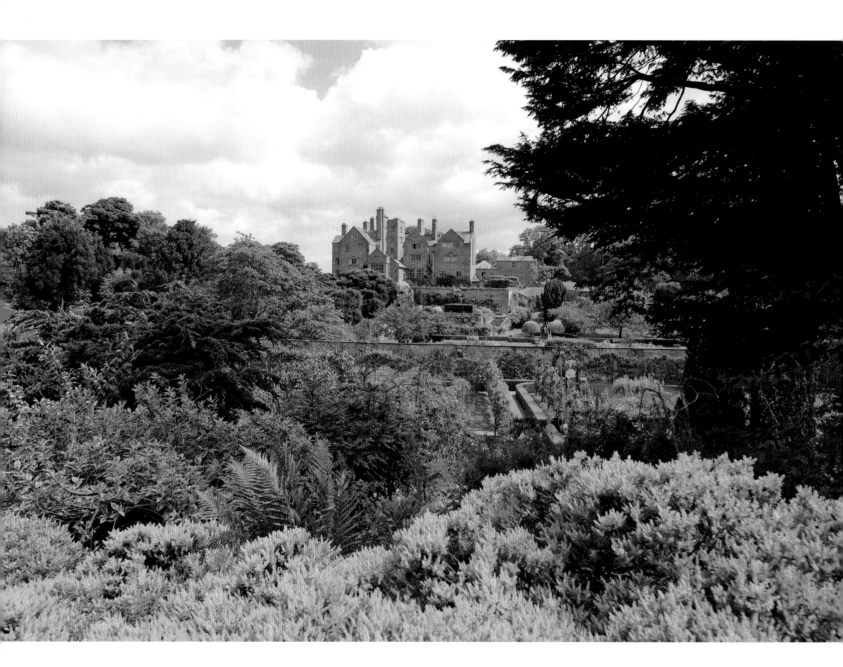

Bodysgallen as it appears from its own woodland. Here the many layers of the garden are laid bare; terraces tumble down from the Hall, followed by the walled rose garden and kitchen garden.

A pastoral view of countryside adjoining Bodysgallen.

to more uncommon types such as tayberries, loganberries and Japanese wineberries. The focus is also on growing local or unusual vegetables, such as baby leeks, blue potatoes and purple carrots, which the chef uses, along with the fruit, to create seasonal dishes for the restaurant. Meanwhile, the cutting garden supplies the hotel with bountiful floral displays.

'It is a truly satisfactory thing to see a garden well schemed and wisely planted,' Vita Sackville-West once wrote. There is no doubt that Bodysgallen is both. Sackville-West's maxim that 'one ought always to regard a garden in terms of architecture as well as colour' is made flesh. Even in winter the garden has much to offer, thanks to its strong structural features and its astonishing parterre, whose pattern is brought into even sharper focus in the frost.

Above all, though, what beguiles most is Bodysgallen's atmosphere of old-fashioned endurance. The garden as we see it today may only be, for the most part, a hundred years old, but there is a reassuring sense that it has been here for centuries, and that it will remain so for many years to come.

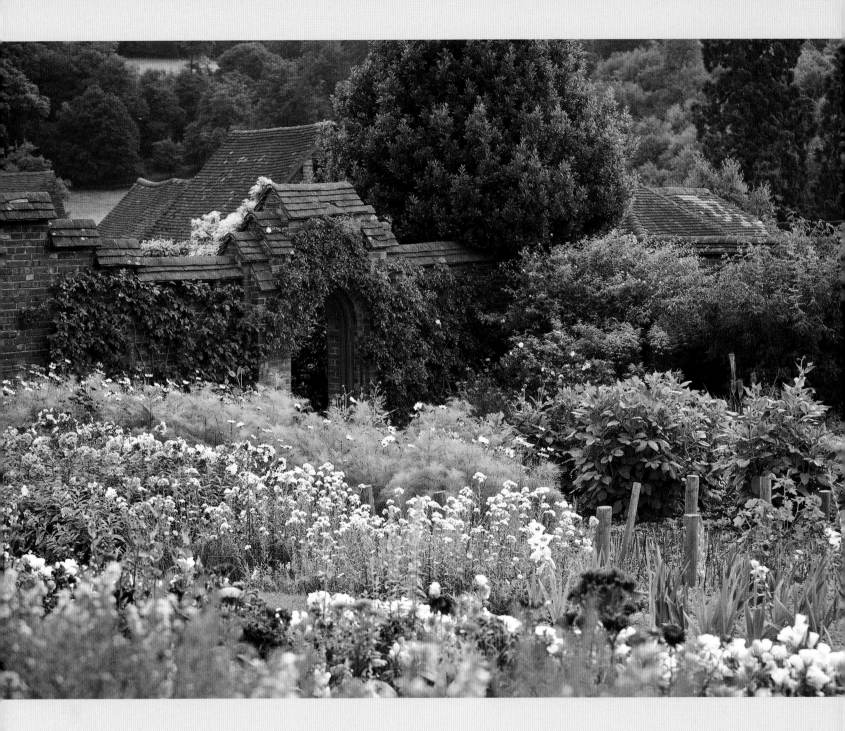

WALLED KITCHEN GARDENS

Sheltered behind mellow brick walls, the riches of walled kitchen gardens are hidden from view, waiting to be discovered. Our Georgian and Victorian forebears thought them unsightly and often placed them as far away from the house as possible. Distance, however, makes their discovery even more enticing.

Until about 20 years ago, many old kitchen gardens lay derelict or neglected. Since then a large number have been restored, including many owned by the National Trust. In 1995, the one-and-a-half-acre Victorian walled garden at Beningbrough in North Yorkshire was one of the first to be brought back to life. Today, like many others, it is maintained by a dedicated band of gardeners and volunteers.

In their Victorian and Edwardian heyday, kitchen gardens were a vital part of any large garden, providing year-round fruit, vegetables, herbs and flowers for the family. Owners prided

TOP A rustic wooden door opens onto the kitchen garden at Llanerchaeron in Ceredigion, Wales.

LEFT: A view through the doorway into the walled garden at Croft Castle, Herefordshire.

FAR LEFT Churchill built the brick wall that surrounds his kitchen garden at Chartwell in Kent with his own hands.

themselves on having the earliest, best and most unusual crops. All manner of tricks and devices – from glass bell jars to labour-intensive heating systems – were used to ensure maximum yield. Special 'hot walls', heated by internal flues, ensured frost did not destroy blossom on fruit trees. Fireplaces situated in little sheds at the back of the walls provided the necessary heat. Glasshouses, fruit walls, vineries, orchard houses and hotbeds protected tender crops, such as melons, nectarines, pineapples and peaches. Rhubarb was 'forced' by using special pots and fresh manure.

Though walled kitchen gardens are not the hive of activity they once were, they still have many attractions. In this 'garden within a garden', those seeking peace will often find it. The temperature is warmer. The air is still. The temptation is to whisper rather than to talk, perhaps in deference to the silent, diligent and sometimes back-breaking work of the kitchen gardener. At Kingston Lacy in Dorset in Edwardian times, the Bankes family were so taken by the beauty of their kitchen garden that they turned part of it into a 'secret retreat'. Here they gathered together as a family – but only once the gardening staff had safely disappeared out of sight.

Lovers of order will appreciate the regular rows, rectangular beds and neat box edging. In spring, fresh growth and the promise of bounty are particularly pleasing, while autumn bears visible fruits. Discovering bright orange pumpkins hidden under their leaves is a joy. So too is hearing the buzz of bees on marigolds, chives and borage – the popular flowers of companion planting.

Perhaps it is this satisfying combination of the beautiful and the practical that makes kitchen gardens so attractive. William Morris famously decreed: 'Have nothing in your house that you do not know to be useful, or believe to be beautiful.' The same can be said of the walled kitchen garden.

ABOVE Neat rows of strawberries, chard and runner beans growing in the kitchen garden in July at Arlington Court, Devon.

RIGHT Divided intro quadrants by box edges, the kitchen garden at Packwood House, Warwickshire, features a cutting border, fruit trees and row upon row of vegetables.

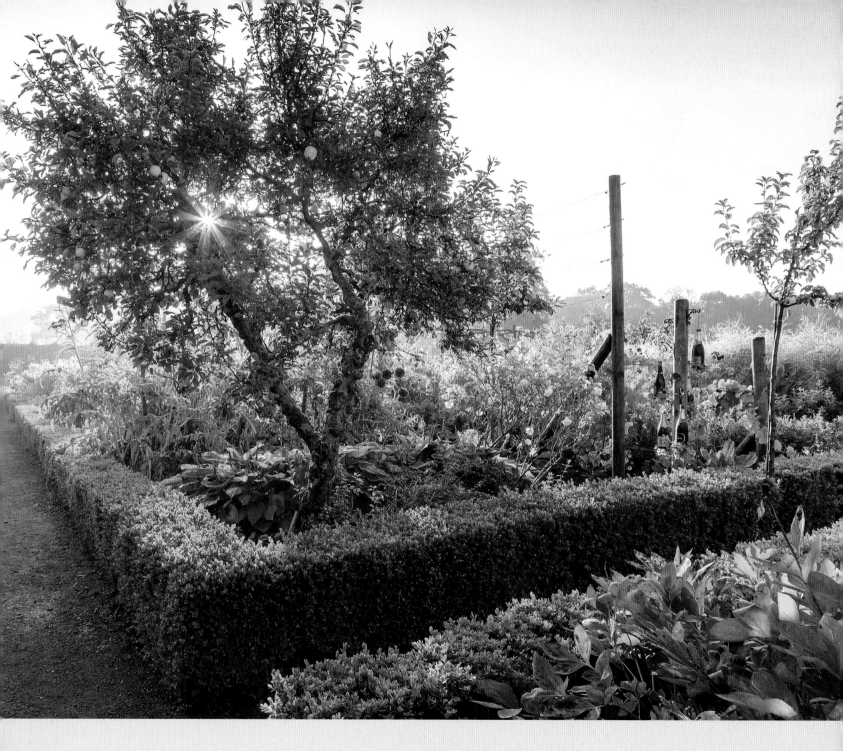

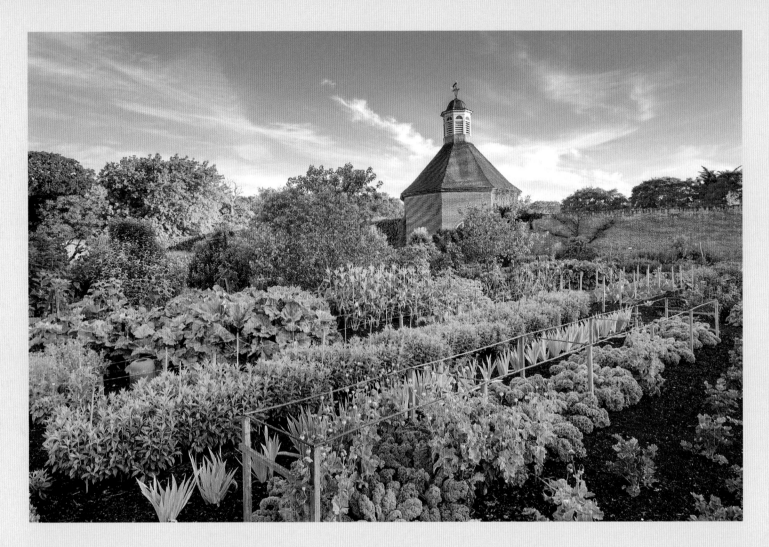

ABOVE The eighteenth-century brick dovecote is the perfect visual counterpoint to the immaculate walled garden at Felbrigg Hall, Norfolk. TOP LEFT Bee on a chive flower in the kitchen garden at Biddulph Grange, Staffordshire. BOTTOM LEFT Sweetpea 'Cupani' and fennel in the walled garden at Ham House, London. TOP RIGHT The kitchen garden at Trengwainton Garden, Cornwall, features raised sloping beds to help combat cold weather. BOTTOM RIGHT Gardener working in the walled garden at Gibside, Tyne and Wear.

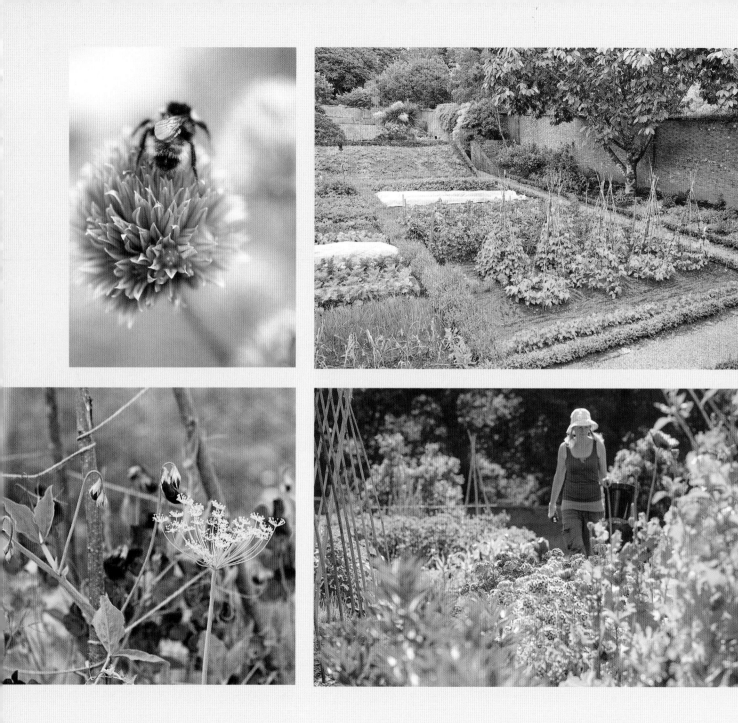

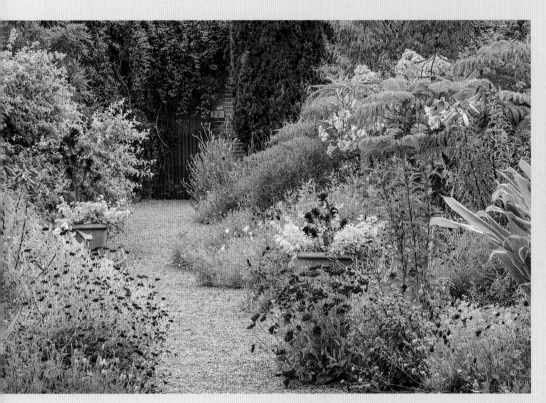

ABOVE The double border in the walled garden at Felbrigg Hall, Norfolk.
Clearly here the focus is on floral beauty and not produce.

RIGHT The setting sun over the Victorian-style kitchen garden at Avebury
Manor, Wiltshire.

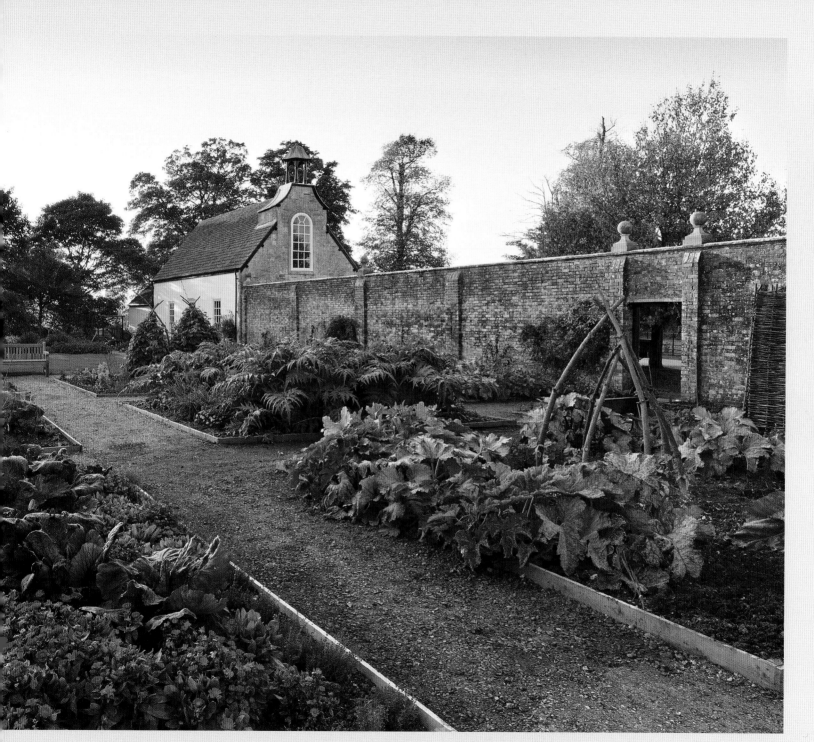

TOWN
GARDENS

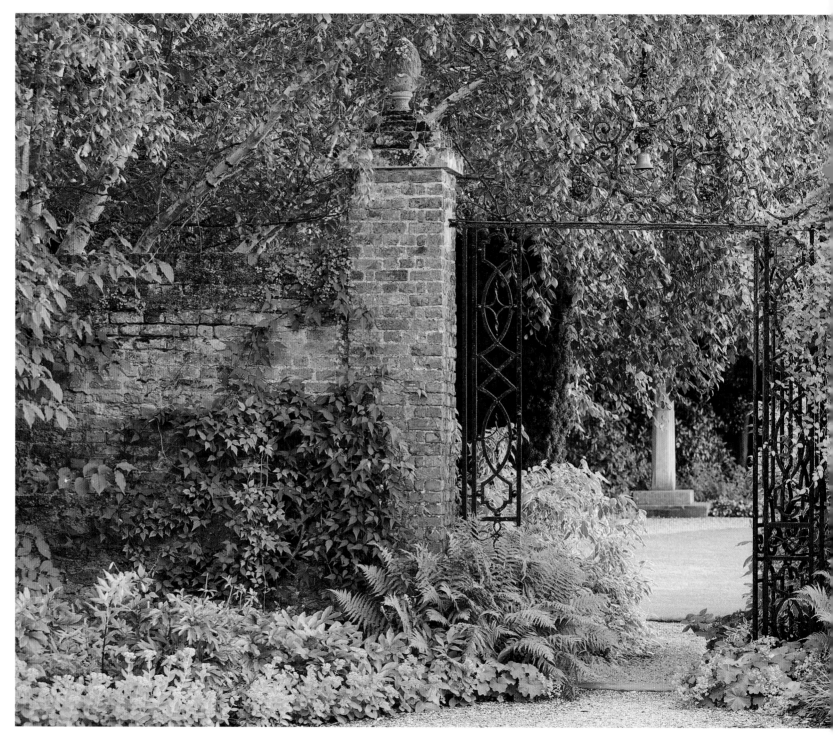

PECKOVER HOUSE AND GARDEN, CAMBRIDGESHIRE

Peckover House lies at the heart of one of Britain's most beautiful Georgian streets. Few people who come to marvel at Wisbech's North Brink are aware that behind these distinguished buildings is a garden of equal refinement.

While Peckover House is pure Georgian, its garden is mostly Victorian. There are exotic specimens gathered from plant-hunting expeditions, greenhouses bursting with blooms and productivity and vibrant carpet bedding. Later developments have added to the garden's charms, with roses aplenty and borders covering every season and almost every colour palette.

From 1794 to 1948, Bank House, as it was known, was home to a family of Quakers, the Peckovers. In 1777, aged 22, Jonathan Peckover opened a grocery shop on the high street. Under his careful management business boomed and customers started trusting him with their money. Eventually, he turned to banking full time, opening Wisbech's first bank in 1792. Two years later he was wealthy enough to acquire the most impressive building in town.

Dating from 1722, this elegant brick town-house was confidently set back and detached from the rest of the row. Its dignified interiors were enhanced with exquisite plasterwork. Large windows at the back framed views of the garden, which did not just extend behind the house, but also included an orchard further along the North Brink. In 1832, Jonathan acquired a neighbouring plot and in doing so was able to join up his two original gardens, creating a sizeable two-acre space. Thankfully, the original walls were kept, making the garden feel bigger than it actually is and offering opportunities for the creation of distinct areas.

PREVIOUS PAGE The Palm Lawn with its island bed and monkey puzzle tree (*Araucaria araucana*) in the background.

LEFT The view from the Pool Garden towards the Orchard Lawn.

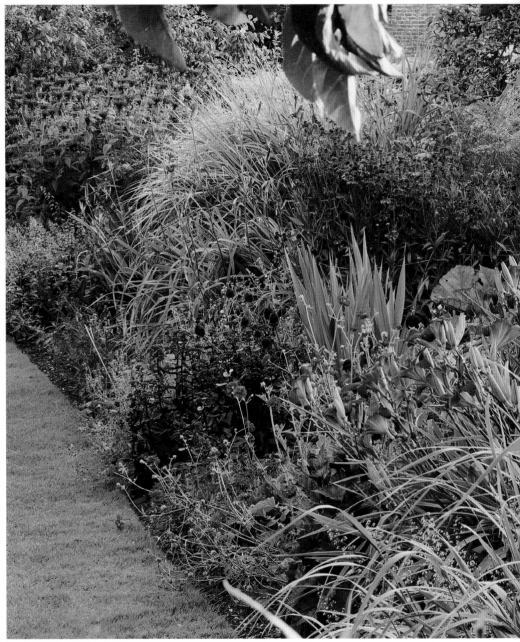

ABOVE In July, *Rosa* 'Sander's White Rambler' scrambles over the arch in Alexa's Rose Garden.

CENTRE *Hemerocallis* 'Stafford', *Monarda* 'Jacob Cline' and *Helenium* 'Moerheim Beauty' are just a few of the warm-coloured flowers in the Red Border.

FAR RIGHT The Victorian summerhouse in the Pool Garden; Peckover has lots of spots where you can sit and take in the views.

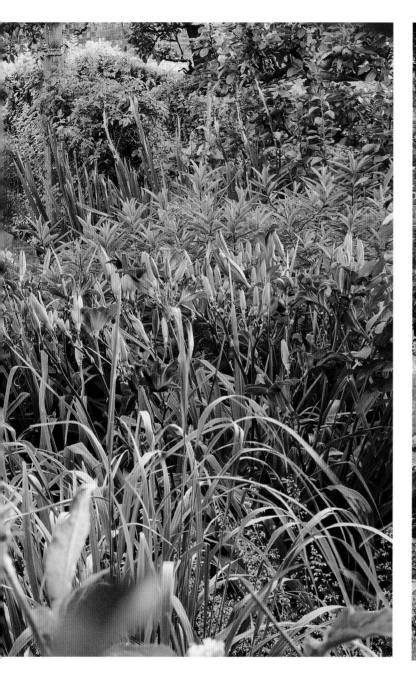
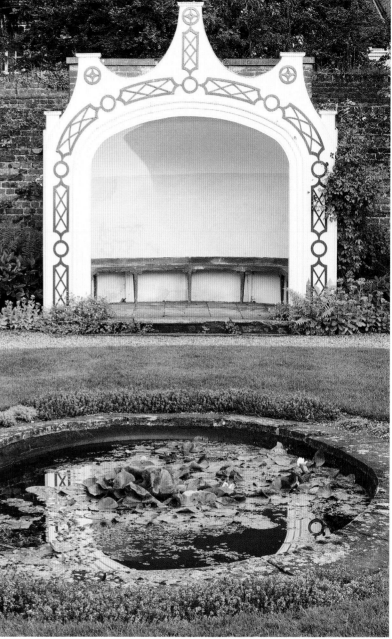

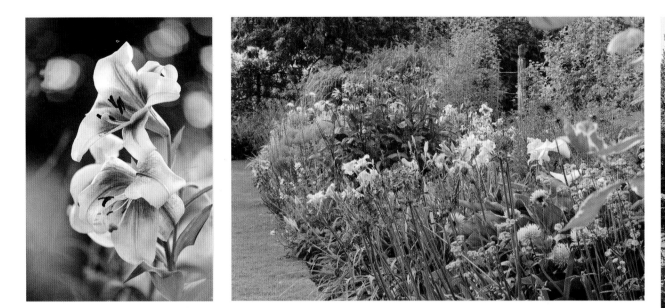

Quakers had a thirst for knowledge and the Peckovers were no exception. They collected widely. Books and artefacts from across the world filled their home and newly discovered species adorned their garden. They rejoiced in the study of plants and the physical labour of garden-making, seeing it as a glorification of God and his world. Jonathan once wrote to his son William, quoting Francis Bacon's words: 'Gardening is the purest of human pleasures.' This enthusiasm filtered down to other family members who lived at Peckover: William's nephew Alexander and his daughters Anna Jane and Alexandrina (who left the house to the National Trust in 1948) all loved the garden.

The glorious eclecticism that is such a feature of Victorian gardens is still felt here today. The scene is one of continuous unfolding and discovery. From a relatively formal croquet lawn edged with evergreen shrubs and groundcover, the garden gradually opens up, offering enticing glimpses in almost every direction, with a network of snaking paths dating back to William's time.

Immediately to your right is the Wilderness Walk, a harmony of greens composed of shade-loving plants such as ferns, ivies, yew and spotted laurel (*Aucuba japonica*). A narrow gravel path takes you round the walled boundary of the garden through a semi-wild and brooding area of light and shade, before emerging once again onto the expansive lawn.

While there is much to see at ground level, the eye is inevitably drawn to the trees.

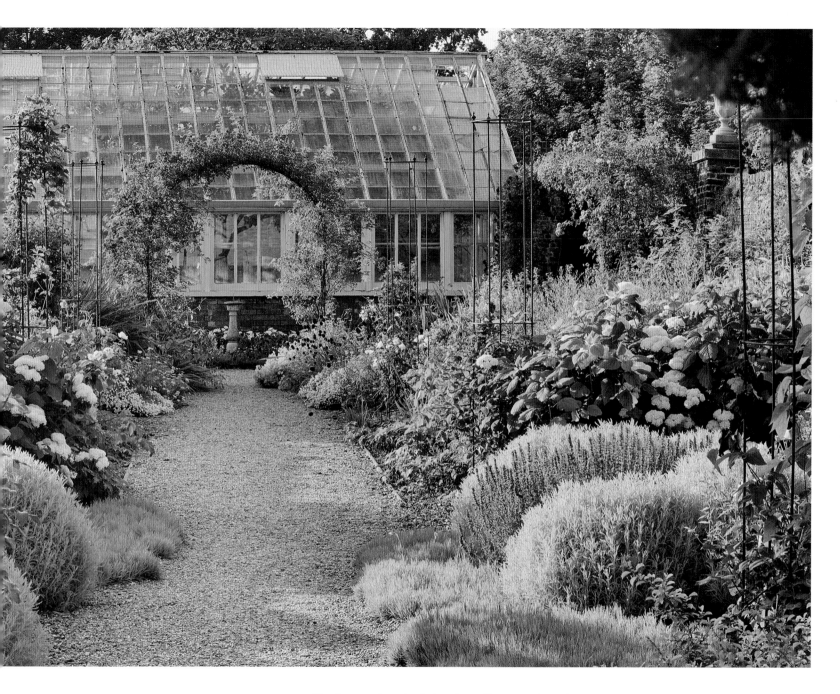

The Orangery from the Graham Stuart Thomas Borders. The rose climbing over the arch is 'Hiawatha'.

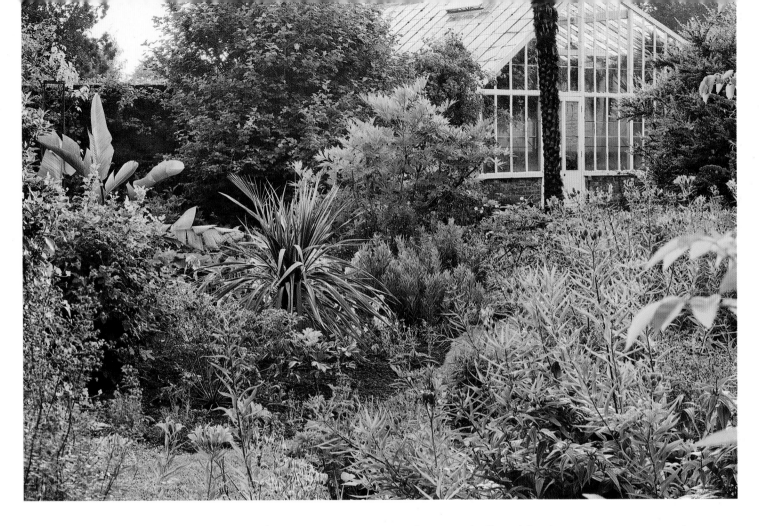

The *Ginkgo biloba* and the tulip tree (*Liriodendron*) were planted by Jonathan, about two hundred years ago. The tallest of the Chusan palms (*Trachycarpus fortunei*) is one of the earliest specimens to have been grown in England, possibly dating from the 1850s. Tall conifers, including a Lawson's cypress (*Chamaecyparis lawsoniana*), Californian redwood (*Sequoia sempervirens*) and monkey puzzle (*Araucaria araucana*) add to the Victorian feel of the garden.

So too does the island bed next to them. Like other smaller borders in the garden, it is host to a twice-yearly display of vibrant annuals, bulbs and tender perennials. Spring pansies,

wall flowers and tulips might give way to summer geraniums, begonias and salvias one year, while the following year the plants might be completely different. 'We can be as creative as we want with the bedding schemes,' says head gardener Allison Napier. 'We like to make them as colourful and interesting as possible, and to experiment with new plants' – very much in the spirit of the Victorian flower garden.

Garden historians have described Peckover as being 'gardenesque' – a term first used by garden writer John Claudius Loudon in 1832 to describe a style designed to highlight the particular character of a plant. This is certainly true of the

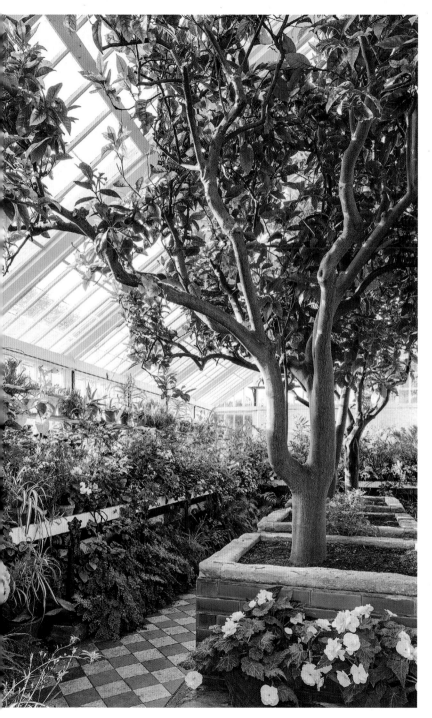

ABOVE Terracotta pots outside the Propagation House.

FAR LEFT Looking towards the the Orangery from the Palm Lawn.

LEFT The Orangery is always full of interest, with hundreds of pot plants and mature orange trees said to be three hundred years old.

bedding schemes where one, two or three species dominate: an opportunity to appreciate the shape, colour and sometimes the scent of one particular flower.

It isn't just in the bedding schemes that individual flowers dominate. Roses take centre stage in Alexa's Rose Garden. This peaceful spot, named after Alexandrina Peckover was re-created in 1999 using original photographs showing rose arches surrounding a small lily pond. Climbing roses such as the small cream and pink 'Phyllis Bide', candy pink 'Madame Grégoire Staechelin' and crimson flecked 'Honorine de Brabant' are a romantic sight in late June and early July, when walls, pillars and arches throughout the garden are heavy with clusters of roses, just in time for Wisbech's long-established Rose Fair. When these blooms fade, the nearby Autumn Border begins to flower, with a generous show of Japanese anemones, hardy fuchsias, aconites, asters and sedums.

Despite being a relatively narrow strip, the section acquired by Jonathan Peckover in 1832 is packed with interest. The Orangery is a delight in spring with hundreds of primulas, narcissi, tulips and hippeastrums, all grown in individual pots. In the centre of the structure stand three proud orange trees, said to be three hundred years old, while opposite is a permanent bed of tropical and sub-tropical plants. 'We like to show the two stages of Victorian conservatory planting in the Orangery. In the early period it was all about colour – that's where the pot plants are. In the later stage, displayed in the permanent bed, people went for a more naturalistic effect with large foliage plants,' explains Allison Napier.

Back outside, a gravel path leads you past deep double borders created in the 1960s by Graham Stuart Thomas, who was an informal gardens adviser to the National Trust. Small hedges divide the beds into colour-themed sections of yellow and gold, silver and blue, blue and pink, and pink and yellow.

After all this floral exuberance, calm is restored in the enclosed Pool Garden with its elegant Victorian summerhouse. But this is a mere parenthesis; there is more. Walk through the delicate wrought-iron gates and you enter the original orchard where the space once again opens up. In William' Peckover's time this was the productive area of the garden and today it still features fruit trees, but it is also home to the delightful Centenary Border. Designed in 1995 to commemorate the hundredth anniversary of the National Trust, it is the loveliest arrangement of pinks, blues, creamy whites and pale yellows. Stars of the show are *Agapanthus* 'Headbourne Hybrids' with deep to pale blue trumpet-shaped flowers, *Hemerocallis* 'Catherine Woodbery' with orchid-pink blooms and the pink shrub-rose *Rosa* 'Octavia Hill', named after the founder of the National Trust,

Allium sphaerocephalon and *Crocosmia masoniorum* in July.

Hydrangea aspera sargentiana on the edge of the Croquet Lawn. With its large velvety leaves and purple heads surrounded by white florets, this large hydrangea is a striking presence in the shrub border.

who lived in Wisbech. Her birthplace, which can be visited, is opposite Peckover House on the South Brink.

Peckover is a garden you could visit every week and not tire of. It is an intensely floral garden, a garden of nooks and crannies, of myriad beds and borders, of quiet areas and shady spots. I haven't even mentioned the Scented Shrubbery, Red Border, Cut Flower Border, Monkey Puzzle Border, Bee Bed, Fern Garden and Propagation House or, indeed, the other Rose Garden and the little graves where generations of Peckovers have buried their beloved cats. Today there are still cats around: Algernon and Damson are Peckover's current cats in residence. If you arrive early enough, you may have this heavenly garden all to yourself, with just a friendly feline companion as your guide.

FENTON HOUSE AND GARDEN, LONDON

A short walk from Hampstead's busy shopping street takes you to a quiet, leafy enclave. In its midst is Fenton House: a dolls' house of a building, all warm brick, sash windows and serene elegance. Hampstead village became fashionable at the turn of the eighteenth century, when mineral springs were discovered on the slopes of the hill, attracting a new breed of wealthy residents. Fenton House, built in 1686, is a product of this time. Ornate ironwork gates topped with generous gilding flaunt the riches of its previous owners. Amongst them was a lawyer, a linen merchant, a tobacco importer and, finally, an art lover: Katherine, Lady Binning, who bought the house in 1936 and filled it with treasures – porcelain, paintings, furniture and fine needlework – until her death in 1952. She left the house and garden to the National Trust, who supplemented the interiors with a collection of early keyboard instruments.

The secret walled garden is a rare gem in London. It is garden of rooms and sunny terraces; a garden of steps and varying levels, of light and shade, of wide views and focused scenes; a garden that feels a lot bigger than its two acres and that takes you on a satisfying journey from formality to greater and greater naturalism.

Here, head gardeners have been able to make their mark while keeping true to a simple design notion: the Old English style. According to head gardener Andrew Darragh, this approach is inspired by the Edwardian era. Arguably, then, the golden age of gardening, the age of Gertrude Jekyll and Edwin Lutyens, whose defining ingredient was a strong structure coupled with generous planting, clean lines and blowsy borders, grandeur and yet also cosiness: a dynamic tension that creates both drama and romance and allows for year-round interest.

Darragh's hero is Christopher Lloyd (Christo to his friends and fans), the maverick gardener of Great Dixter, whose adventurous approach served him well and inspired many. Nowhere is this attitude better expressed than in the front garden, the site of Darragh's most recent undertaking. The avenue of old false acacias – overgrown and overpowering – is no longer here. In its place, he has planted a graceful cherry avenue, whose delicate pink flowers are an uplifting sight in spring. In summer, a new serpentine border parades bold drifts of sun-loving plants – *Perovskia* 'Blue Spire', *Centaurea montana* (Great blue-bottle) and towering echiums to draw passers-by.

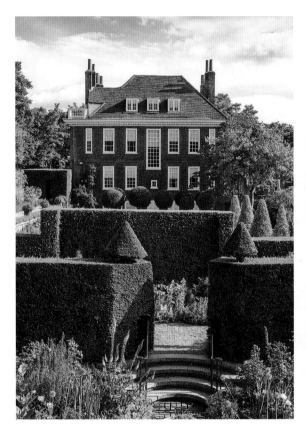

ABOVE This view from the south-facing top terrace shows the Rose Garden in the foreground, the Cross Border in the middle ground and the tops of the 'lollipop' hollies on the Formal Lawn.

RIGHT In the spring border, the yellow spikes of verbascums stand out against the dark green backdrop of the yew hedge.

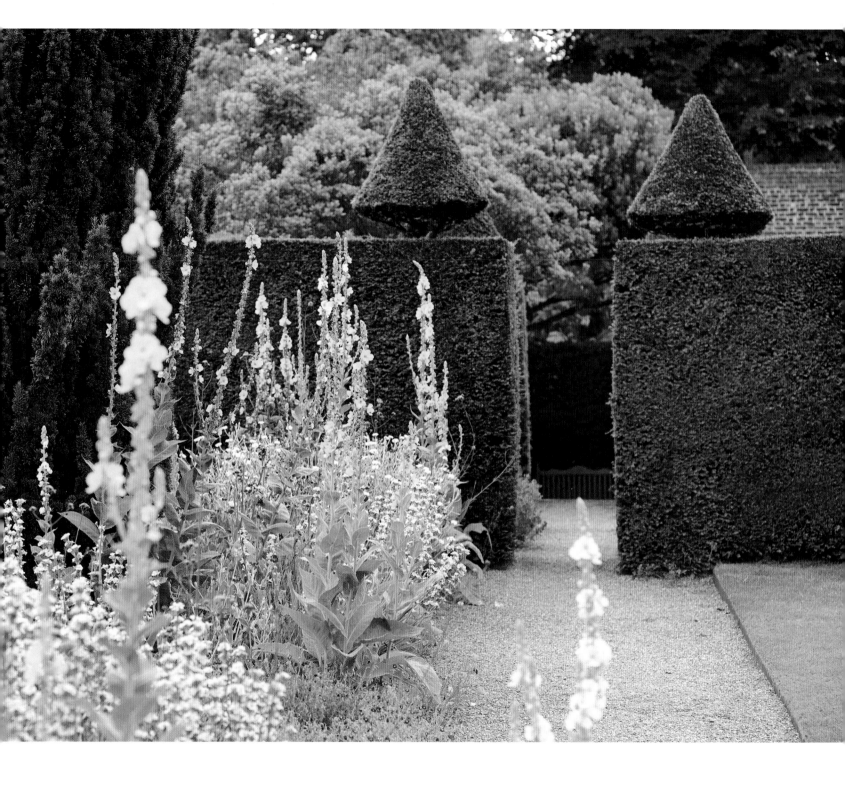

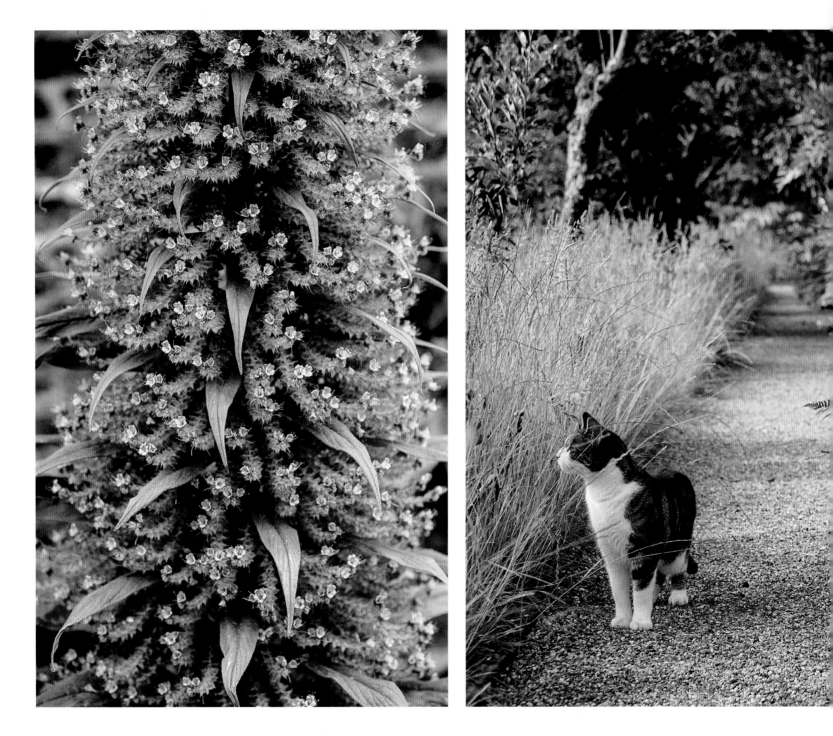

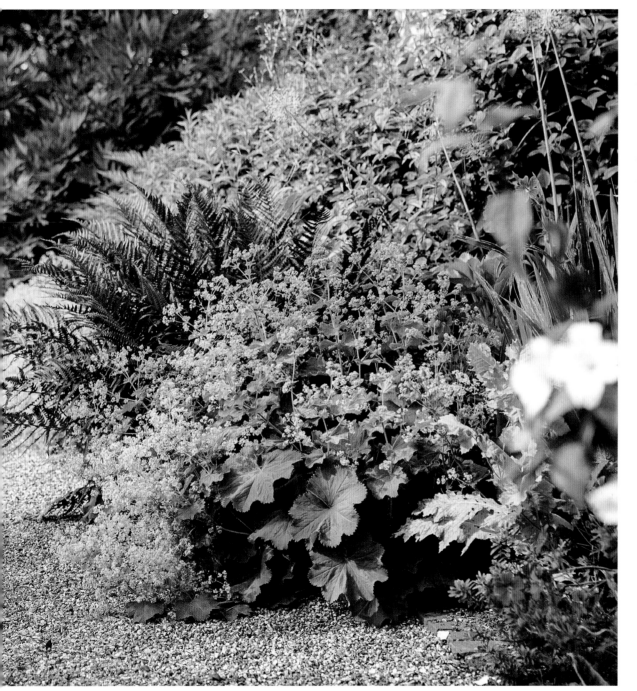

FAR LEFT *Echium pininana* is a sculptural presence in the garden. Its tall spikes are dotted with delicate purple-blue flowers interspersed with pointed leaves.

LEFT The long border lining the orchard is edged with *Alchemilla mollis*, ferns and hardy geraniums.

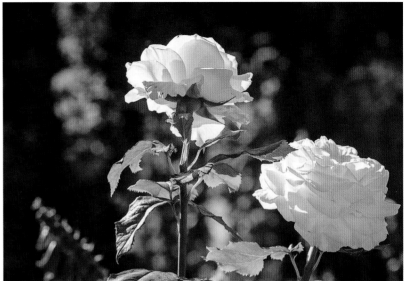

ABOVE *Rosa* 'Gloire Lyonnaise' in the Rose Garden.

LEFT A view from the Formal Lawn, showing the terrace above, with a rose clothing the brick wall.

Walking round the house and through a yew arbour you emerge to a view of the Formal Lawn. This large green carpet, lined with holly cones (*Ilex aquifolium* 'Argentea Marginata') and neatly clipped standard holly 'lollipops', is edged east and west with long borders, and contained to the north by a knife-sharp yew hedge. It all feels like a stage-set. Against the dark green of the yew stands a single statue, flaunting a relaxed pose and unclassical features.

In high summer, the east-facing border is hot and fiery – clashing blues and oranges of salvias, crocosmias and dahlias create a heady mix. Opposite is the quietly confident Spring Border. Irises, graceful dieramas (also known as angels' fishing rods) and *Sisyrinchium striatum* blend with naturalised cowslips, stately verbascums and *Verbena bonariensis* in a pleasing design based on butter yellows, whites and purples, combined with strong uprights and sword-shaped leaves. Here, as elsewhere in the garden, there is no gradation of height – another Christo-inspired feature. Verbascums spill onto the gravel path, stopping you in your tracks. There is a feeling of abundance and of nature at work throughout the garden: self-seeded opium poppies, echiums and myriad foxgloves pop up along your journey, graceful leitmotivs whose random appearance creates, as if by magic, a common thread.

There are different ways to experience this garden: from the top terraces, you see its enclosures from above – an attractive, almost two-dimensional view. The terraces too are lined with borders, offering a summer-long show. Descend into the different garden rooms and the spaces feel more real and complex; top and bottom

Inside the Cross Border, stately echiums reign supreme among penstemon, foxgloves and later flowering phlox, *Perovskia* 'Blue Spire' (Russian sage), and low-growing *Persicaria affinis*.

LEFT Steps lead down to the orchard, where a lean-to greenhouse is used to protect tender plants in the winter; the small herb garden can be glimpsed near the greenhouse.

RIGHT Foxgloves, alliums and opium poppies have been left to colonise part of the vegetable garden.

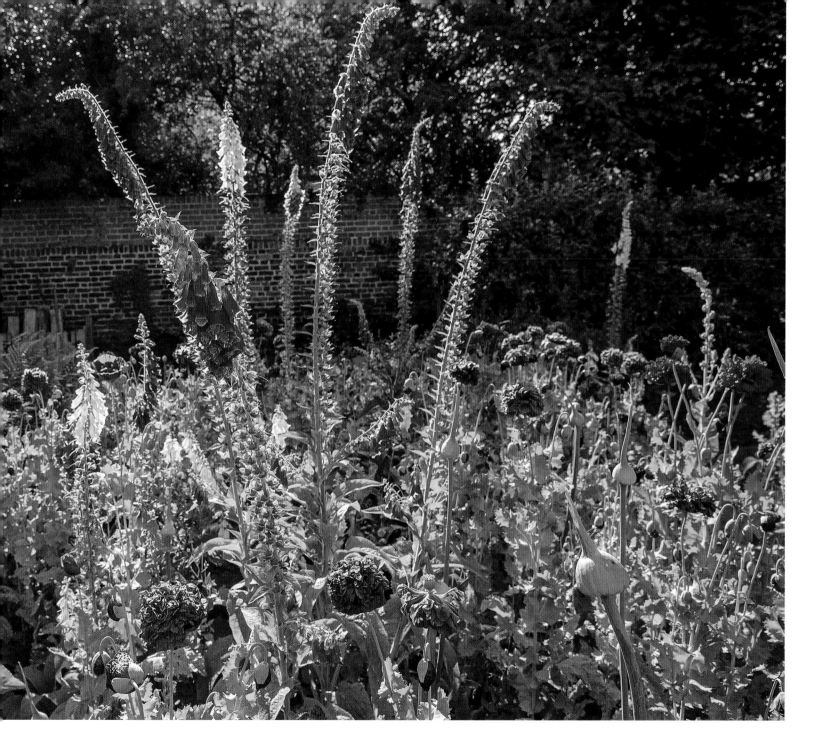

Allium hollandicum
'Purple Sensation' grows
in almost every part
of the garden; its star-
shaped flowers appear
in early summer.

Opium poppies
(*Papaver somniferum*)
are allowed to self-
seed, adding subtle
shades of pink and
purple to the garden.

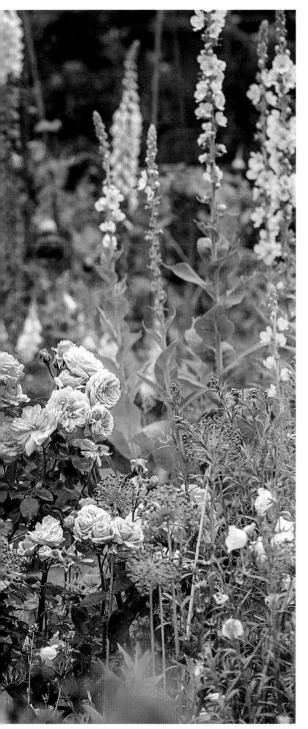

levels start to speak to each other, adding depth and drama. This is particularly true in the sunken Rose Garden, approached from semi-circular steps. In one corner, *Rosa* 'Albéric Barbier' is repeated on the top terrace, creating a rich, layered picture. Against one of the walls, a newly planted wisteria will eventually cascade down the railings, echoing the garden's old wisteria at the end of the north terrace.

This is not your traditional rose garden, with neat bushes and bare soil. Here the underplanting (and indeed overplanting) is as important as the roses. Generous displays of geraniums, penstemons, phloxes, foxgloves and – unexpectedly, but successfully – teasel, create a soft, cottage-garden effect, with *Alchemilla mollis* blurring the edges.

The next room, known as the Cross Border, is narrow and almost entirely enclosed by a yew hedge. It feels like a little corridor, but with floriferous borders along its length. Sedums, sages, geraniums, *Fuchsia magellanica*, Penstemon 'Sour Grapes', *Perovskia* 'Blue Spire' and yet more echiums and foxgloves tangle together – their naturalistic effect enhanced by the unclipped, beard-like hedge. While on the outside the yew is kept dead straight, Andrew likes to let it grow a bit of stubble inside.

The orchard is one of the most enchanted spaces in London. Gnarled apple trees inhabit this peaceful spot, witnessing a yearly display of spring bulbs – wood anemones, followed by crocuses and Narcissi 'Jack Snipe', and the almost uncanny chequered blooms of *Fritillaria meleagris*. In summer, lacy umbels of cow parsley and delicate meadow grass sway in brush-like waves. You could almost forget you are in the city. Here too is a bountiful border, mixing whites, lush greens and large leaves: *Rosa* 'Long John Silver', *Fatsia japonica*, a grand *Tetrapanax papyrifer* 'Rex', clumps of ferns and hellebores, and the ever-beautiful *Alchemilla mollis*. Beyond an espalier of apple trees lies the neatly ordered, old-world vegetable and cut-flower garden.

Fenton House has everything one could desire in a garden. It has all the ingredients of good design – surprise, drama, a strong structure softened by generous planting and, to top it all, a beautiful and productive fruit and vegetable garden. The mood of the planting varies as you walk about but the overall impression is one of tranquillity and beauty, a wonderfully peaceful haven in the city.

LEFT Roses, foxgloves, allium seedheads, campanulas and verbascums combine to create a cottagey feel in the cut flower garden.

ORCHARDS

Often situated on the edge of the ornamental garden, orchards are an unexpected delight. Just when you think your garden tour is nearing its end, you happen upon another treasure. Neither forest nor garden, old orchards are a controlled wilderness whose charms are manifold. In spring, bulbs cover the ground in a pastel carpet of crocuses and narcissi. Soon after, blossom takes over, sprinkling the trees in delicately scented confetti. If the meadow grass is left to grow, summer wildflowers are the haunt of butterflies and bees. And in the autumn, all is mellow fruitfulness: branches, heavy with harvest, offer up their bounty in the soft October light.

There is a gentle nostalgia about orchards. Their romantic associations remind us of a simpler past – a time of feasts, harvest festivals and picnics. They can inspire childhood memories, and call to mind paintings and poems. Like forests, old orchards are imbued with a sense of mystery, inspiring tranquillity and contemplation. Cloister-like, they envelop us, protect us. And like forests, they help us commune with nature in a profound way. Old orchards are astonishingly rich habitats, offering food and shelter for over 1,800 species of wildlife, from bats, birds and butterflies to lichens, mosses and mistletoe.

Years of decline saw over 60 per cent of all British orchards disappear in the second half of last century. Thankfully in recent years they have enjoyed a renaissance. The National Trust is working with regional orchard groups and community orchards, helping to reclaim this vital part of Britain's natural and cultural heritage. From Scotland to Cornwall, old orchards are being restored and new ones planted. Traditional and regional fruit varieties are being revived, in a bid to escape the dangers of monoculture and in celebration of taste and locality. In 2007, the

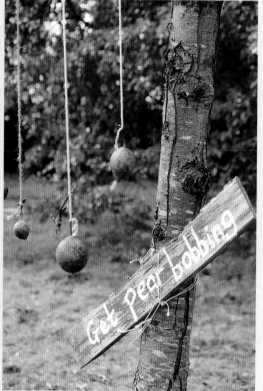

ABOVE Pear bobbing at Dyrham Park, South Gloucestershire – one of many orchard-related, family-friendly activities held during Apple Day.

LEFT Beehives and trees in blossom create a romantic picture in the orchard at Sissinghurst Castle Garden, Kent.

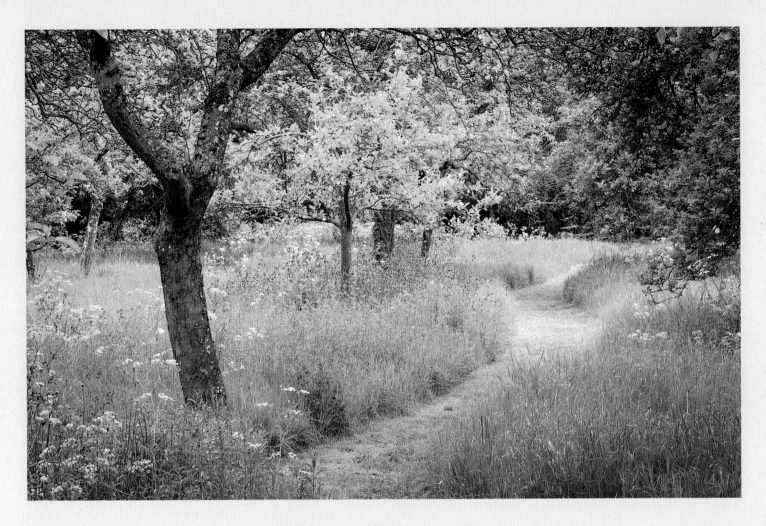

A mown path invites you to explore the orchard at Hidcote, Gloucestershire, where red campion and cow parsley flower in May.

National Trust planted a new Mother Orchard at Cotehele in Cornwall's Tamar Valley, an area known for its apples. The 5-hectare (13-acre) orchard is now home to over 120 different Cornish and Devonshire varieties.

Every October, Apple Day festivals are held in orchards across the country. Activities such as apple bobbing, apple-and-spoon races and the longest apple peel competitions give both young and old a chance to enjoy these wonderful habitats. Meanwhile, apple tastings highlight the huge range of flavours in our native apples. Some of the names will make you smile too, such as Catshead, Slack Ma Girdle and Pig's Nose.

When the harvest is over and winter takes hold, you might witness a large flock of fieldfare or redwing feasting on the fallen fruit. It is an arresting sight. As clergyman William Lawson wrote in *A New Orchard and Garden* (1618): 'What can your eye desire to see, your eares to hear, your mouth to taste, or your nose to smell, that is not to be had in an orchard?'

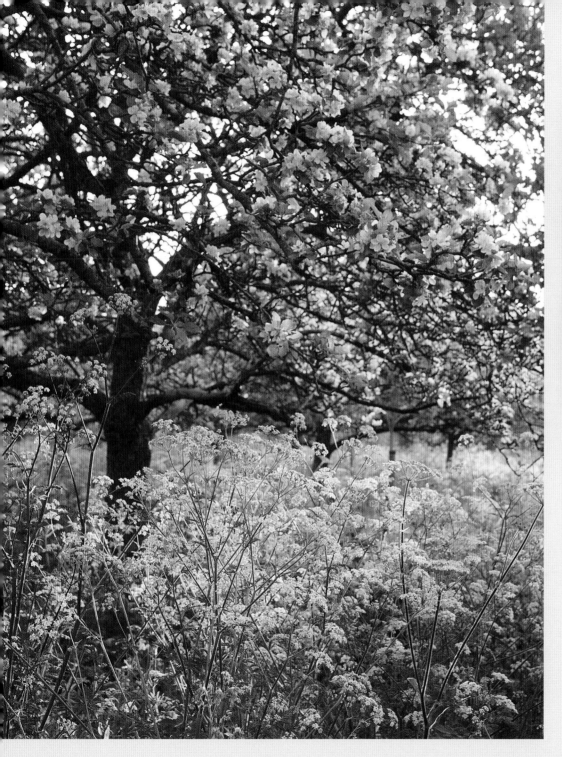

ABOVE Mistletoe growing in an apple tree in December, in the orchard at Cotehele, Cornwall.

LEFT In April and May the cider orchard at Barrington Court, Somerset, shelters a blanket of cow parsley.

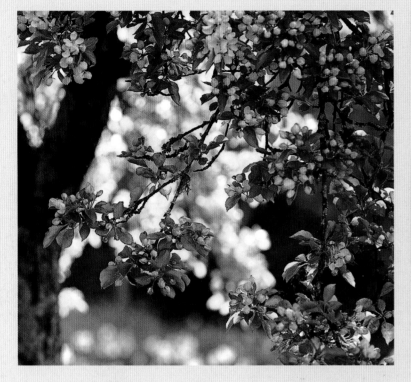

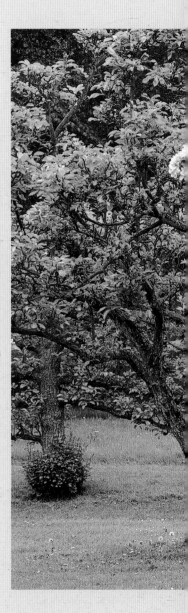

Apple tree in blossom in April, in the orchard at Cotehele, Cornwall. The two apple orchards here are home to local varieties that have been cultivated in the Tamar Valley for centuries.

Apple blossom just about to flower in the walled orchard at Acorn Bank, Cumbria, home to over a hundred local apple varieties.

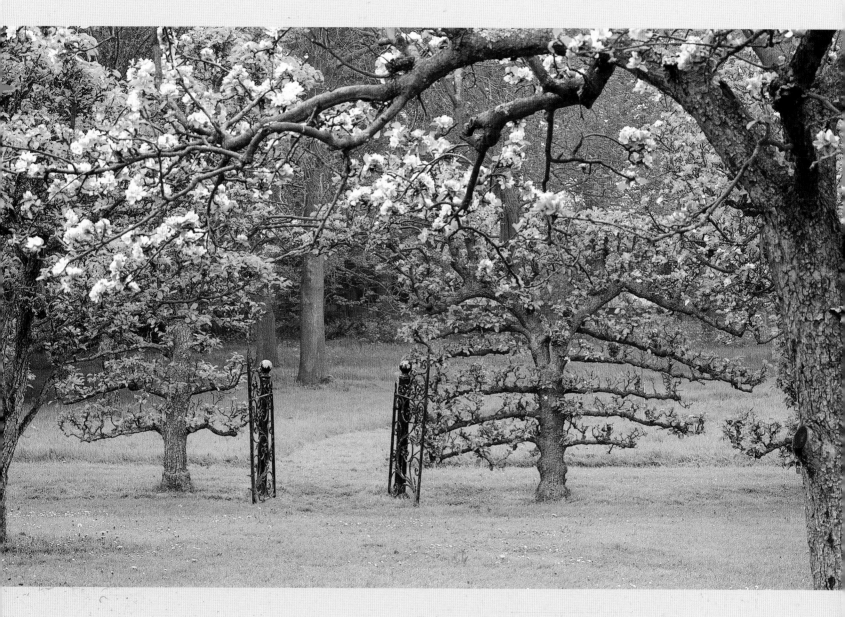

The orchard at The Courts Garden, Wiltshire, in spring. The gate in the centre of the espaliered trees leads to an arboretum.

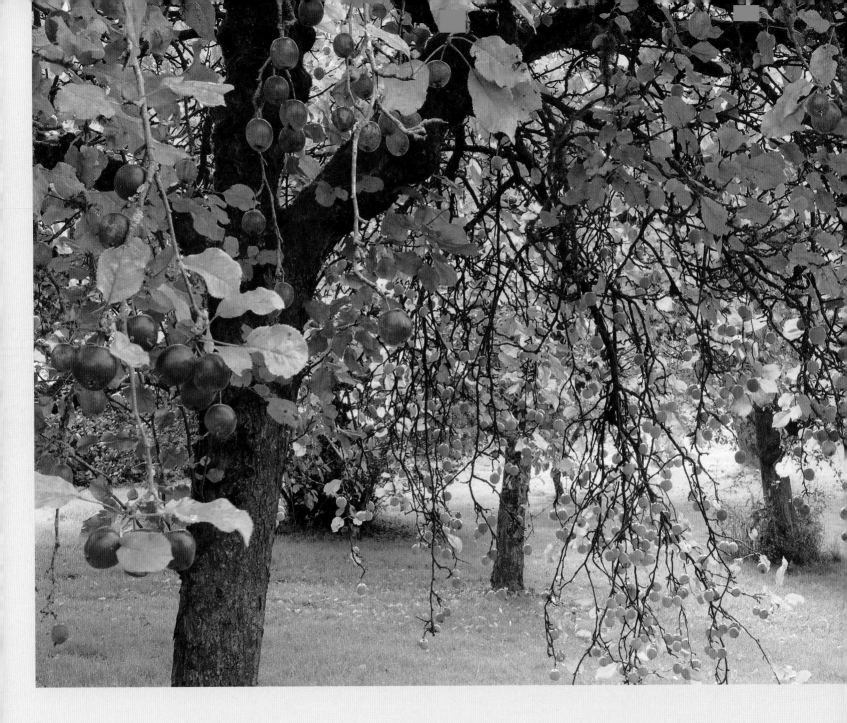

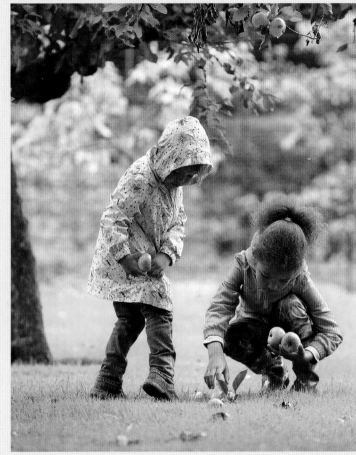

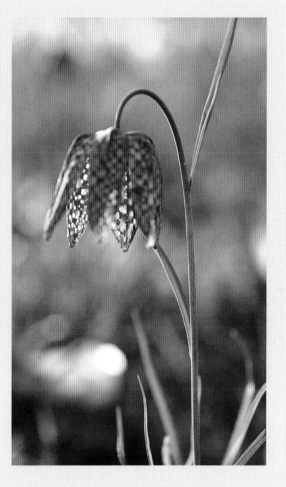

ABOVE Children collecting apples in the orchard at Bateman's, East Sussex, once home to Sir Rudyard Kipling.

LEFT Crab apples ready for picking in the orchard at Sizergh Castle, near Kendal, Cumbria, in September.

ABOVE In May and June the chequered lanterns of snake's head fritillary (*Fritillaria meleagris*) are a wonderful sight in some orchards, including those at Chastleton House in Oxfordshire and Fenton House and Garden in London.

ARTS AND CRAFTS GARDENS

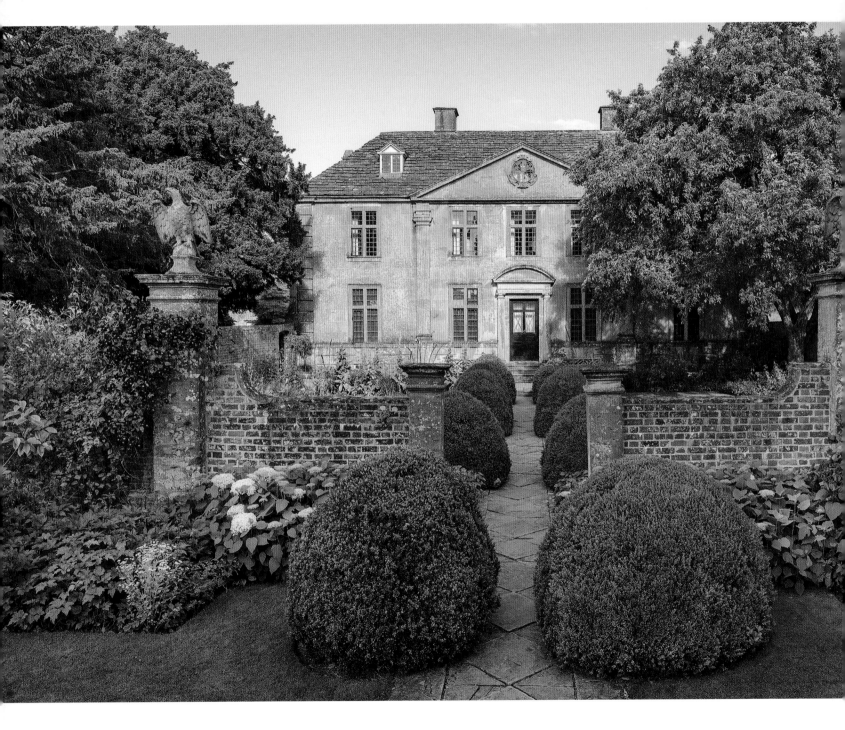

TINTINHULL GARDEN, SOMERSET

Hidden in a secret corner of Somerset, Tintinhull is the creation of two talented women. Phyllis Reiss, a gifted amateur, devoted the last three decades of her life to this charming two-acre garden. Her successor, garden designer and writer Penelope Hobhouse, spent 14 years tending its intimate outdoor rooms, memorably describing it as 'the offshoot of Hidcote'.

Tintinhull does indeed have much in common with Hidcote, the outstanding Cotswold garden designed by Lawrence Johnston in the early twentieth century. Before moving to Somerset, Reiss and her husband had lived nearby and were well acquainted with this Arts and Crafts masterpiece. Tintinhull, though much smaller, adheres to the same principles. It is a garden of rooms divided by walls and hedges, in which paths take you on a journey of carefully planned vistas, unexpected glimpses and changes in mood. Throughout, the garden's framework is softened by generous planting.

But Tintinhull is no pastiche. It was among Vita Sackville-West's favourite gardens; one of its rooms is said to have inspired her famous white garden at Sissinghurst. Whereas Lawrence Johnston employed a dozen full-time gardeners, Reiss relied on the help of a local stable-boy. Tintinhull is a garden on the domestic scale. Its planting, which mixes small trees, shrubs, perennials, biennials and bulbs, is both inspiring and achievable.

Phyllis Reiss gave Tintinhull to the National Trust in 1954 but lived in the house until her death in 1961. It was then occupied by

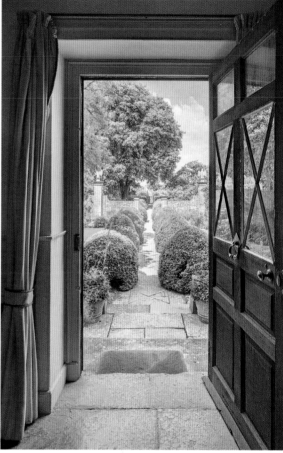

PREVIOUS PAGE Tintinhull is made up of a series of small garden rooms delineated by old walls and evergreen hedges.

LEFT Evening sunlight casts a golden glow on the house, as proud eagle statues overlook the Middle Garden.

ABOVE The first tantalising glimpse of the garden is through the main door of the house.

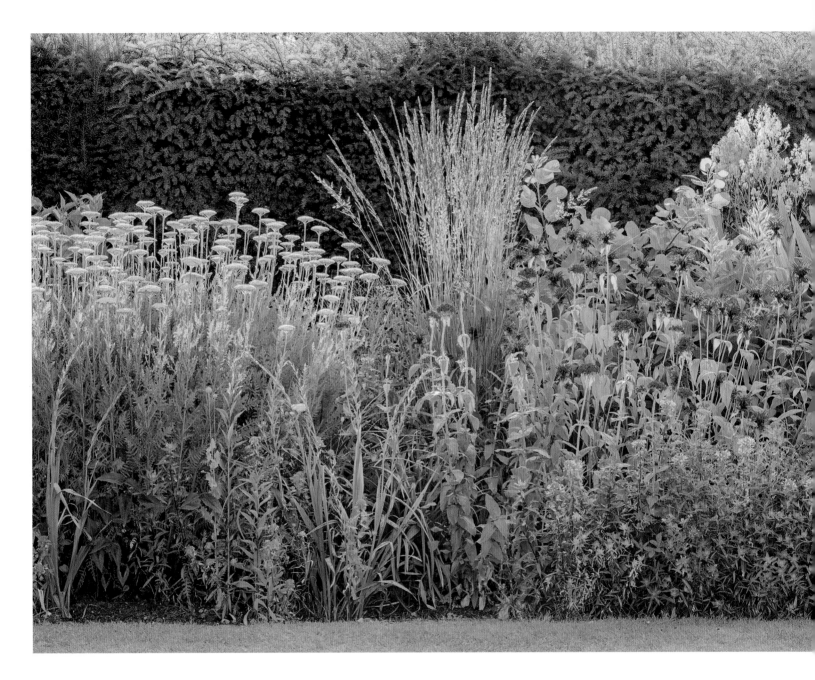

ABOVE Golden achilleas, red monardas and grasses in the hot border of the Pool Garden.

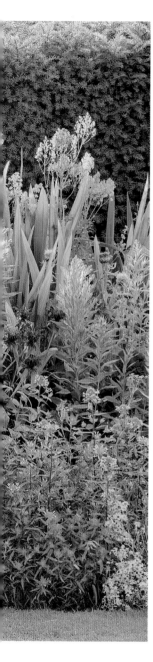

ABOVE In high summer, large pots filled with exotic planting add drama and colour to the Pool Garden.

ABOVE RIGHT The courtyard in summer where bananas, castor oil plants, fiery dahlias, deep blue salvias and all manner of annuals are arranged in spectacular borders.

RIGHT *Clematis* 'Perle d'Azur' grows against a brick wall in Eagle Court.

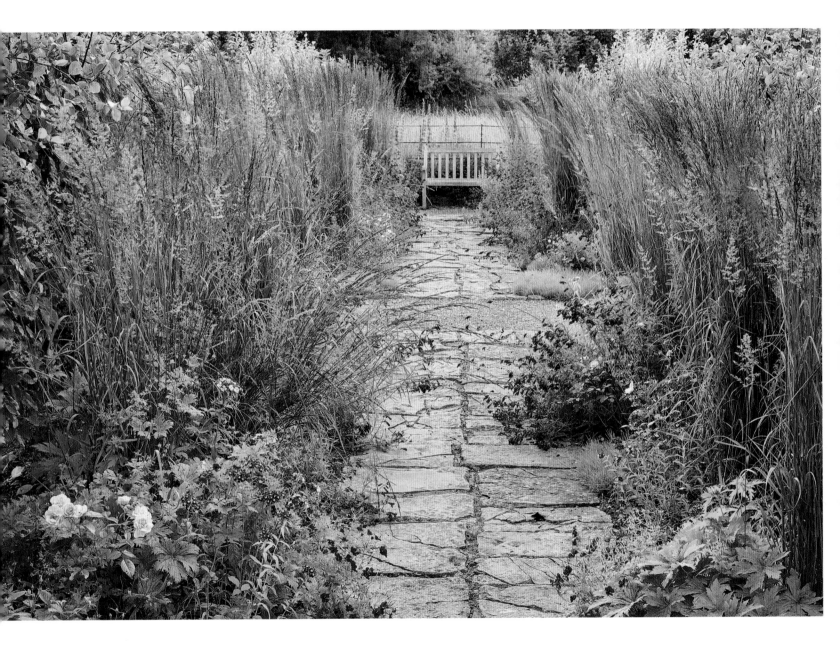

A solitary seat in the kitchen garden. Tintinhull has many quiet spots where you can while away the hours with a book.

The kitchen garden has just the right mix of flowers, fruits and vegetables. Its main walkway is lined with lavender-blue *Nepeta* 'Six Hills Giant'.

tenants, the most significant of whom was Penelope Hobhouse. Despite not owning the property, between 1980 and 1993 she and her husband Professor John Malins tended the garden with meticulous attention. Hobhouse has been modest about her contribution: 'I have been the decorator rather than the designer, using Mrs Reiss's inspired "bones"… as the background to all planting.' What she did add, however, was a multitude of pots – on terraces and courtyards, under porches and inside garden buildings, next to seats and benches. The glorious result was an added sense of luxury and an extended flowering season. Penelope Hobhouse believed that 'gardens change as they develop'. After years of neglect, she made necessary and judicious changes to the planting. This spirit carries on today, with head gardener Jessica Evans embracing her predecessors' ideas, but also adding personal touches.

Walking past golden stone walls to reach Tintinhull's charming seventeenth-century manor, there is no hint of the garden beyond. You have to go through the house to get your first sight of it. And what a sight it is. A row of distinguished box balls, evenly lined along a central path, stretches out before you, drawing your eye down the length of the garden. Soon your gaze is drawn to the area closest to you: Eagle Court, the first of Tintinhull's garden rooms. Elegant red-brick walls, ornamented by a pair of stone columns topped with proud eagles, enclose you in this intimate space. Being closest to the house, Reiss believed this area should provide a long season of interest. Along the walls, blue-and-yellow themed borders create a near-constant show: hellebores start off the year, followed by euphorbias, irises, aconites, salvias and hydrangeas. In spring and summer, flower-filled pots enliven the terrace and steps, while climbers, mainly roses and clematis, including the lavender blue 'Perle d'Azur' clematis, clothe the walls.

Reiss used repetition to create harmony and believed that leaves are as important as flowers – principles that come sharply into focus in the naturalistic Middle Garden. Orange-leaved *Spiraea japonica* 'Goldflame', planted in each of the four beds circling a small lawn, forms the basis for a pleasing assortment of shrubs, small trees and ground cover. Dark-leaved plants, such as *Berberis thunbergii* 'Red Pillar', *Cercis canadensis* 'Forest Pansy' and *Cotinus coggygria* 'Royal Purple', add depth to the rich tapestry of shades.

Despite her keen eye for design, Reiss was also an amateur plantswoman and would sometimes be drawn to unusual or interesting varieties. Following in her footsteps, Jessica Evans has recently introduced *Fatsia polycarpa* 'Needham's Lace' into the Middle Garden. A striking architectural plant with deeply cut leaves ranging from fresh to dark green, it seems the perfect choice for this garden room dominated by tones and shapes.

RIGHT The classical urn in the Middle Garden provides a focal point in this garden room dominated by subtle arrangements of shrubs.

FAR RIGHT As with the rest of the garden, the Fountain Garden offers carefully planned vistas. Here the eye is drawn to the catmint-lined path of the kitchen garden.

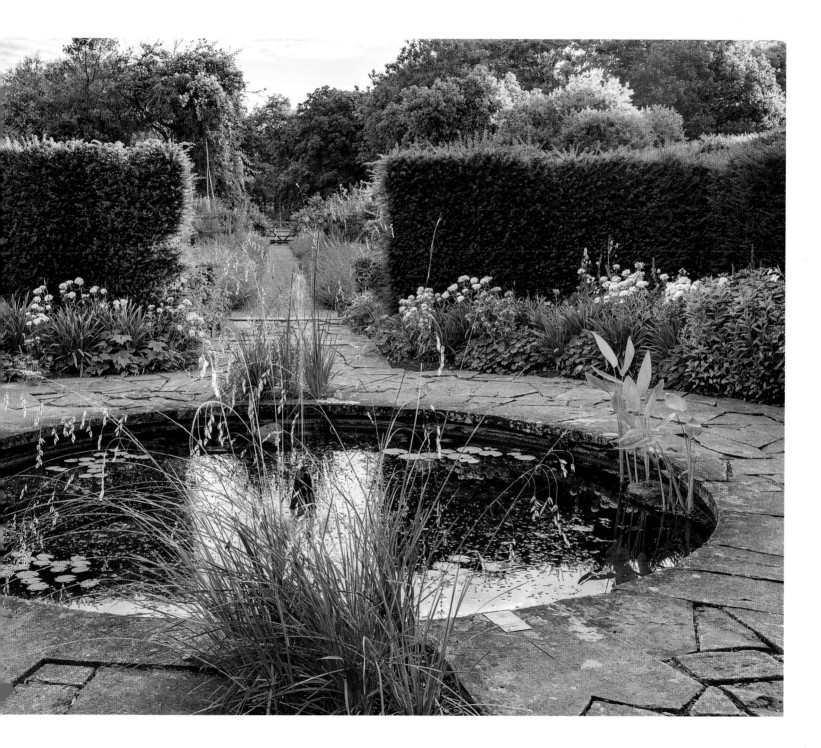

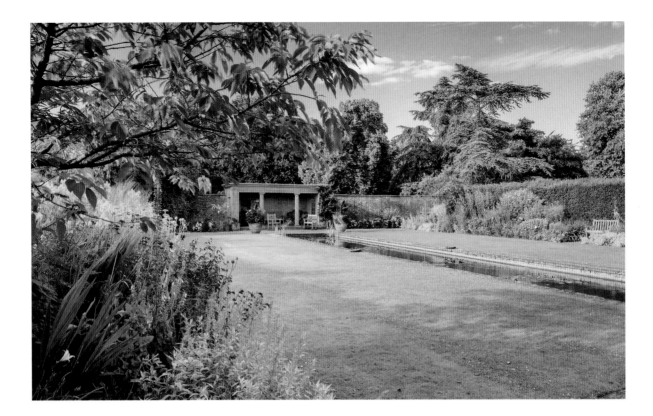

Yet another atmosphere is created in the Fountain Garden. Enclosed by yew hedges, a circular pond takes up most of this small space, enlivened by corner borders of white blooms. Aconites, hostas, astrantias, irises, roses and asters combine in a well-orchestrated crescendo of heights. The swan-necked spikes of *Lysimachia clethroides* sway gracefully next to *Agapanthus campanulatus* var. *albidus*, with its umbels of trumpet-shaped flowers, while velvety-leaved *Geranium renardii* nestles below. Hiding behind the yew hedges is another surprise: a tiny spring garden. From March to May two little wedding cake trees (*Cornus controversa* 'Variegata') are joined by the daintiest of narcissi: creamy-white *Narcissus* 'W.P. Milner', old-fashioned *N. poeticus* 'Actaea' and surprised-looking *N.* 'Jack Snipe'.

After these intimate rooms, the garden opens out onto a traditional kitchen garden, with neat rows of vegetables, espaliered pears and flowers for cutting. Adjoining it is a small orchard with resident sheep – a delightful reminder that you are in Somerset.

Inspired by holidays in Italy, Phyllis Reiss and her husband transformed an old tennis court into a contemplative space, known as the Pool Garden. A classical loggia overlooks a rectangular pond, flanked on either side by a strip of lawn and a long border. At the right time of day, the water reflects the sky, adding to the

sense of stillness and repose. Despite the compositional symmetry, the borders could not be more different. One bursts with hot shades of red crocosmias, poppies, salvias and potentillas and gold achilleas, lilies, dahlias and heleniums. The other, a vision of romance, blends soft pinks, lavender blues, greys and purples. Huge pots on the edges of the pool and by the summerhouse add extra colour and structure. Reiss created the Pool Garden in 1947 in memory of her favourite nephew, a pilot who was shot down during the Second World War. Knowing the solace that a garden can bring, she made hers available to anyone going through a period of trauma.

'I love the idea of secret hidden surprises to be discovered in progression,' wrote Penelope Hobhouse. This is what Tintinhull offers, and it does so with grace and ease. Cedar Court, the last of Tintinhull's rooms, is edged with yet more delicate, colour-themed borders. Among the lawns, a trio of graceful magnolias, underplanted with spring snowflakes and muscari, is a vision in April and May.

Tintinhull may be an introspective garden, but Phyllis Reiss was generous about sharing it. She placed seats in key spots, believing a garden should be enjoyed, not just worked in. 'Phyllis has an unusual habit for a practical gardener,' wrote Marjory Fish. 'She was always looking for a place to sit and contemplate things.' Nowadays, visitors are free to while away the hours. Some have even been known to fall asleep in the garden, such is Tintinhull's soothing influence.

Pinks, creams, soft purples and subtle yellows dominate the pale border in the Pool Garden.

SNOWSHILL MANOR AND GARDEN, GLOUCESTERSHIRE

Snowshill Manor is nothing short of extraordinary. Charles Paget Wade – architect, artist, craftsman, poet and one of England's true eccentrics – spent his life collecting all manner of objects, eventually accumulating over twenty thousand items, which he displayed in his astonishing Cotswold home.

Though Wade trained as an architect, family fortune meant that he never needed to pursue a career. In 1919 he gave up work and acquired this traditional, mostly seventeenth-century manor house in which he would live out his motto: '*Ne quid pereat*' ('Let nothing perish'). The house was a ruin, the garden a jungle of nettles, but it was in the perfect spot, perched on a steep slope overlooking gentle hills and a picture-perfect village.

Wade spent the next three years restoring the house and creating the bulk of the garden, which, in true Arts and Crafts style, is an extension of the house. His former colleague, the architect M. H. Baillie Scott, produced preliminary designs for the garden, but it was Wade who fleshed them out, creating a series of intimate rooms, 'sunny ones contrasting with shady ones and different courts for varying moods'.

Wade collected pieces for their craftsmanship and the stories they told, not their value. Simple tools, pipes, spinning wheels, prams and bicycles were to him as beautiful and worthy of his purse as exquisite cabinets, model ships, clocks and suits of armour. The varied nature of his collection is part of its appeal. But there is nothing museum-like or predictable about the interiors. Wade gave his rooms evocative names – such as Nadir, Seraphim, Meridian and Zenith – and presented his treasures in atmospheric set-pieces. 'A room can be filled with innumerable objects,' he wrote, 'and yet have a perfect atmosphere of repose, if they are chosen with thought and care so as to form a harmonious background.'

The house was entirely for his collection. Wade confined his living quarters to a small outbuilding outside the manor, where he slept in a tiny box bed. He was not, however, a

A wooden bench nestles within a hedge in this quiet corner of the garden.

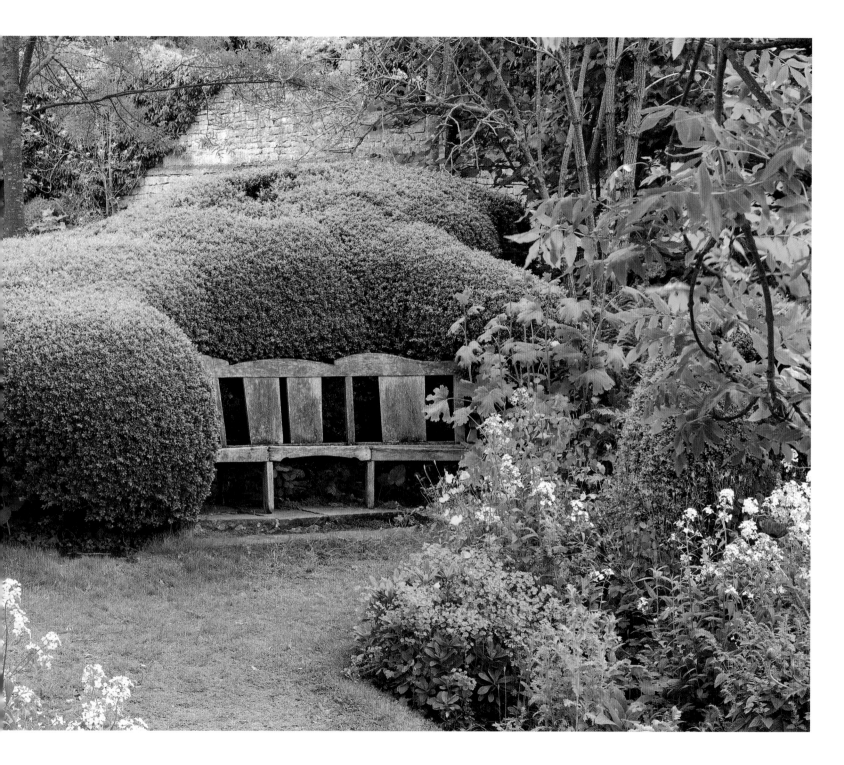

recluse, and delighted in sharing his secluded home and garden with friends and celebrities, including Virginia Woolf, architect Clough Williams-Ellis, Graham Greene, John Betjeman and J.B. Priestley. Queen Mary, after a visit, noted that Wade, who enjoyed dressing up, was the most remarkable object in the collection.

In his small terraced garden, Wade kept and restored the rustic outbuildings, adding water features and clearly marked-out beds. As in the house, he gave his outdoor rooms names and embellished them with antiques, such as sculptures and well-heads. The sense of peace and repose that he wanted to create indoors is even stronger in the garden. This is indeed a quiet place, a place of bucolic views and charming detail – but a place, above all, of wonder, where you come across the unexpected, such as Latin and old English inscriptions and a miniature village.

Wade knew that mystery is the key to good design: 'Never show all there is at once. Plan for enticing vistas with a hint of something beyond.' Summing up his ideal, he wrote: 'A delightful garden can be made in which flowers play a very small part, using effects of light and shade, vistas, steps to changing levels, terraces, walls, fountains, running water, a statue in the right place, the gleam of heraldry or a domed garden temple.'

With so many separate elements, the garden could have easily felt disjointed, but the sense of harmony is strong, thanks in part to Wade's decision to use a powdery shade of turquoise blue,

The inscription on top of this gate reads: 'A Gardyn Walled All With Stoon, So Fair a Gardyn Wot I Nowhere Noon'.

now known as Wade blue, on much of the woodwork in the garden. This was the perfect complement to the mellow tones of the Cotswold stone, the green of the grass and the hills. His preference for blue, mauve and purple flowers further enhanced the overall picture.

The Well Court encapsulates the elements of formality, fantasy and surprise that characterise the garden. A small central lawn with a Venetian well-head in its centre is trimmed with paving and edged on two sides with borders brimming with flowers, including lupins and other purple and blue plants, such as veronica, phlox, *Acanthus mollis* and *Echinops ritro* 'Veitch's Blue'. There are water features too: a square pool with neat box balls dotting its corners, and two small fountains in the walls. Look closely and you will see that Wade has added a small frog near one of them. Doves fly in and out of the dovecote on the side of the court. In Wade's day, peacocks would also have roamed the garden, their bright blue bodies and bold plumage adding vibrancy to the scene.

At the opposite end of the Well Court stands a former cow byre, which Wade transformed into a mock baronial hall, complete with banqueting table. In its gable he placed a carved figure of the Virgin Mary, whose niche is painted blue, as are the benches that stand below it. He transformed the upper floor of the building, which he named Sancta Maria, into a small summer bedroom for himself, right in the centre of the garden.

The Sancta Maria byre, with its shrine to the Virgin Mary in the gable, in the Well Court.

RIGHT One of the most arresting sights in the garden: a zodiac clock (or *nychthemeron* clock) decorated in blue and gold in the Well Court.

FAR RIGHT The Well Court, with its lily pond, central lawn and adjoining borders, is an elegant, architectural space.

Sancta Maria leads into Elder Grove, where a small copse of *Viburnum opulus* (elders in Wade's day) is underplanted with a variety of ferns and hellebores, *Fritillaria meleagris*, violet-blue scillas and dainty erythroniums. The play of light and shade is at once calming and uplifting – the perfect counterpoint to the drama of Well Court.

Further up the garden is Wolf's Cove, named after the miniature fishing village Wade created here. A large pool pretends to be the sea, rimmed by picturesque models of houses and boats. In Wade's day, the Cove was connected to a working railway and canal. John Betjeman was so inspired by this creation that he wrote a description, published in *Architectural Review* (January 1932). His words make it sound so real that the reader is entirely taken in by it; only in the last paragraph does Betjeman reveal it to be a fantasy village.

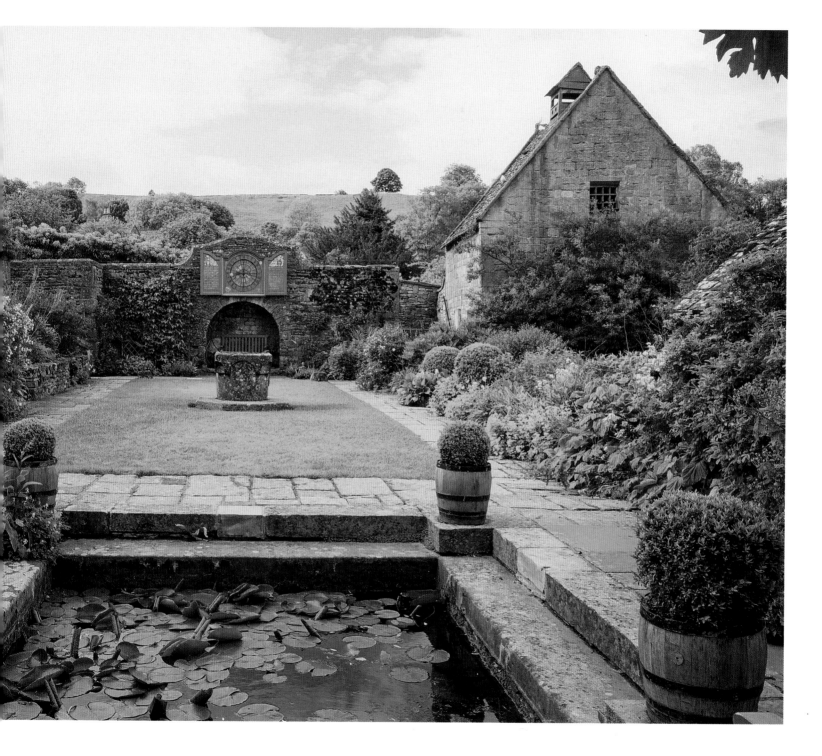

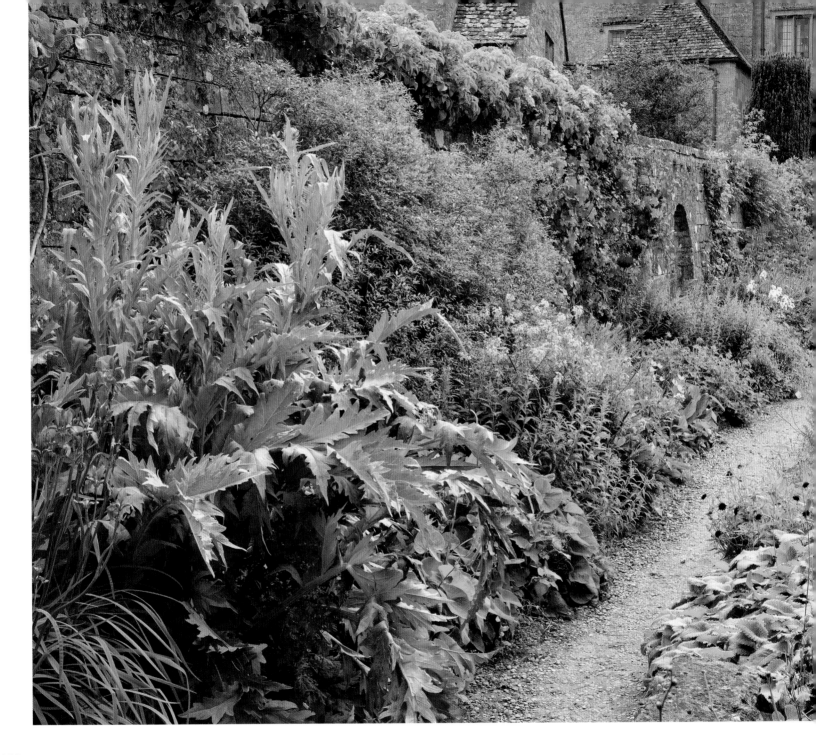

Next door, in the Armillary Court, veronicas, hemerocallis, nepeta and asters knit together in the facing borders, creating a pleasing tapestry effect. As you step out of the main terrace, the views open out. The orchard is a sight in spring, carpeted with campion, ox-eye daisies and wild scabious, while Long Border reaches its peak of beauty in mid- to late summer, when giant scabious (*Cephalaria gigantea*), magnificent cardoons (*Cynara cardunculus*) and bright magenta *Gladioli byzantinus* steal the show.

Wade was more than an obsessive and quirky collector. He was a lover of beauty in all its forms. Ever the poet, he once wrote of the perfect garden: 'Tis a man's rest, children's fairyland, bird's orchestra, butterfly's banquet.' Snowshill certainly lives up to this lyrical description.

The Long Border offers a colourful display of cardoons, alchemillas, irises and poppies in June.

TOP LEFT Pine cones hang by a door, acting as useful gauges for atmospheric conditions: if the cones open up, the weather is dry.

LEFT Hart's tongue fern (*Asplenium scolopendrium*) and *Corydalis lutea*, with its little trumpet-like yellow blooms, growing on steps.

LEFT A corner of Wolf's Cove, with one of its miniature houses, showing the Armillary Court beyond.

ABOVE The Bacchus fountain in the Armillary Court. The garden at Snowshill is full of unusual and quirky features such as this one.

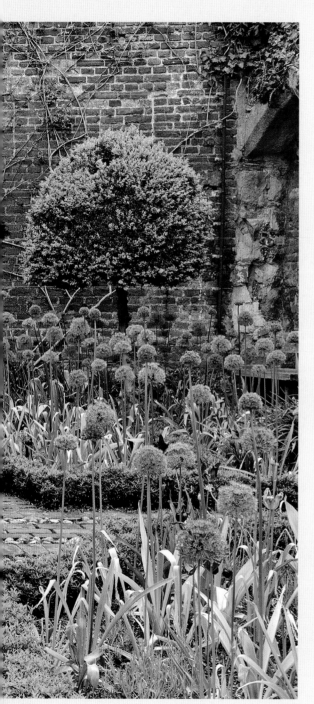

GARDEN ROOMS

'The garden is where I go for refuge and shelter, not the house,' wrote the novelist Elizabeth von Arnim. Many gardeners would agree with her, and there is perhaps no better refuge than a garden 'room'. Cloistered within a boundary of hedges, walls or fencing, this garden within a garden offers a promise of peace, seclusion and beauty.

Hidcote is no secret garden. Garden lovers know it well, or are at least familiar with this work of horticultural art – it is possibly the most influential English garden of the twentieth century. Yet it contains rooms so private as to be almost hidden, each one with a charm all of its own. Encircled by a thick yew hedge, the Bath Pool Garden is a tranquil spot where sky, trees and shrubs are reflected in a calm circle of water, enlivened only by a small fountain of a boy and dolphin. To its side is the Italian Shelter, a thatched loggia within its own little courtyard adorned with terracotta pots, which transports you straight to the Mediterranean. Also off the Bath Pool Garden is the Green Circle. Here, in the quietest of all Hidcote's rooms, with just a green lawn and thick yew hedge for company, a solitary seat invites you to pause and reflect in glorious isolation.

Garden rooms are an essential feature of Arts and Crafts gardens. The series of enclosures offers variations in mood, opportunities for discovery and surprise and, through the use of hard-landscaping and green 'walls', a near-seamless connection with the house. Describing his ideal garden, William Morris wrote: 'It should be well fenced from the outside world. It should by no means imitate either the wilfulness or wildness of nature, but should look like a thing never to be seen except near a house. It should in fact look like part of a house.' In his garden at Red House, on the outskirts of London, Morris created small areas enclosed by wattle fences and rose-covered trellis with beds of old-fashioned native flowers. He looked to medieval and Tudor times for inspiration – to the courts of manor houses, to the monasteries of the age, and to a type of real and symbolic garden known as *hortus conclusus* (meaning, literally, enclosed garden) portrayed on altarpieces, tapestries and illuminated manuscripts.

Greys Court in Oxfordshire is a garden of charming enclosures. Here in the Cromwellian Garden alliums bloom in May against a backdrop of mellow brick walls.

RIGHT Roses scramble in romantic abundance up the walls and pillars of the Inner Court at fifteenth-century Great Chalfield Manor, Wiltshire.

BELOW The Italian Shelter with its painted murals at Hidcote in Gloucestershire. In the early summer *Pelargonium* 'Scarlet Unique' adds to the Mediterranean feel of this unexpected space.

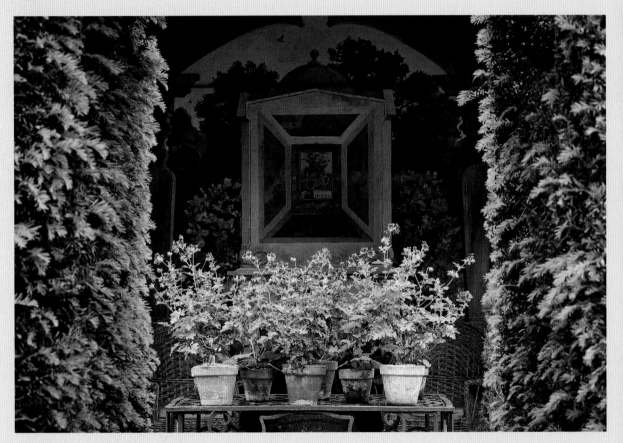

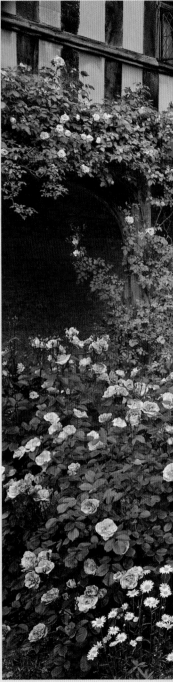

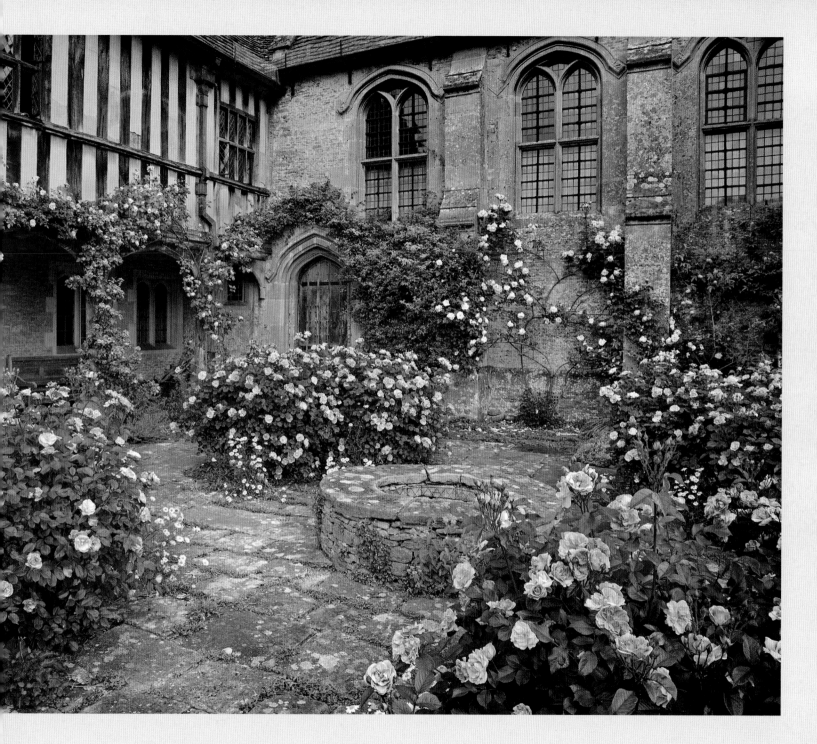

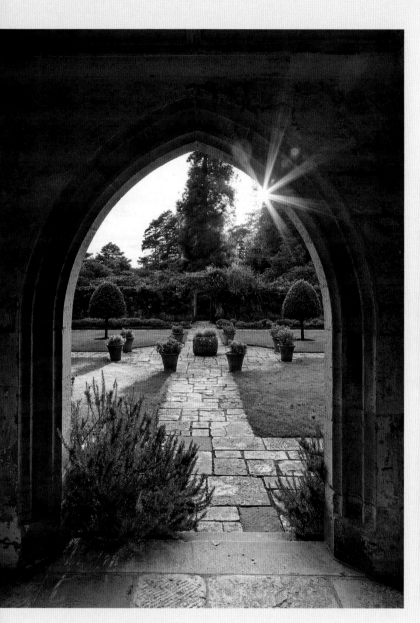

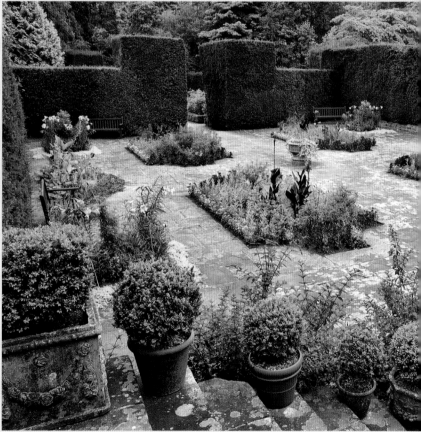

LEFT The Forecourt Garden at Nymans in Sussex is very much an extension of the house. Secluded from the rest of the garden by ancient-looking walls and Tudor in feel, it was the private domain of its last full-time resident, Anne Messel.

BELOW Dyffryn Gardens in the Vale of Glamorgan features a series of themed garden rooms, each with its own character. In July, the island beds in the Paved Court are filled with Victorian-style bedding plants.

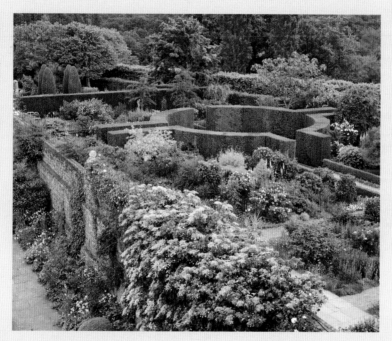

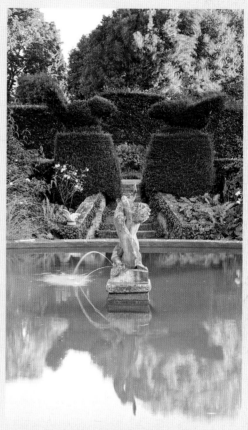

RIGHT The Bath Pool Garden in September at Hidcote, Gloucestershire, reflecting the autumnal shades of the trees beyond.

BELOW Sissinghurst in Kent is a collection of exquisite garden rooms, each beautifully contrived by Vita Sackville-West and her husband Harold Nicolson.

In religious symbolism the *hortus conclusus* was associated with the Virgin Mary, and gave rise to the creation of 'Mary' gardens. This closed-off garden represented her virginity, while the plants within symbolised her virtues. A fountain, flowery mead, arbour and turf seat might add to the scene, which took on, in secular interpretations, a romantic overtone attached to the theme of courtly love. This feeling of enchantment, this sense of heaven on earth, still hangs heavy in many a garden room.

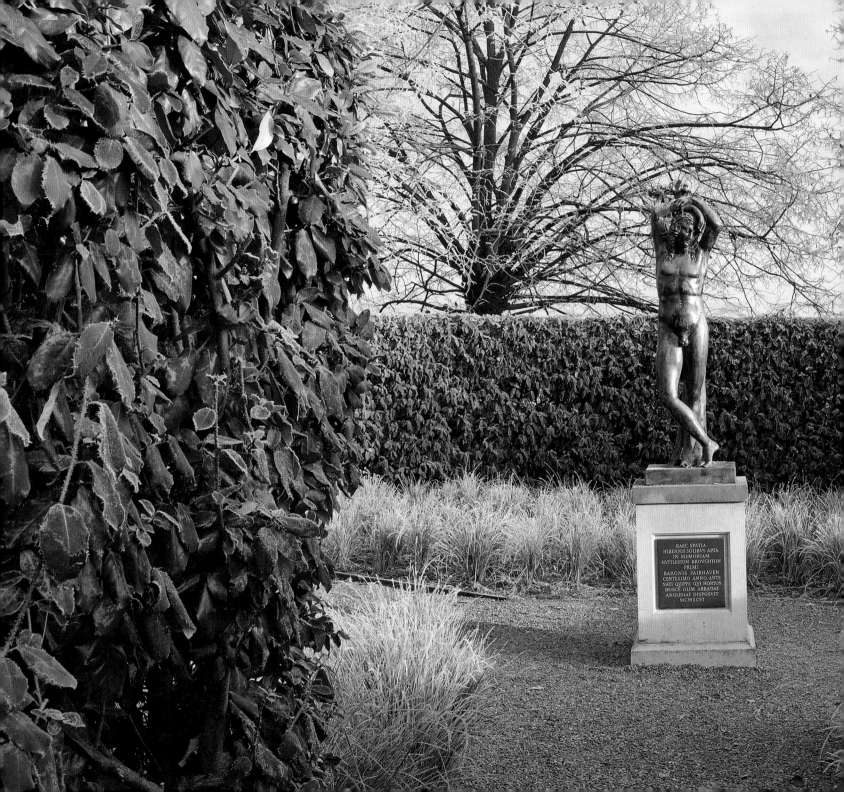

HAEC SPATIA
HIBERNIS SOLIBVS APTA
IN MEMORIAM
HVTTLESTON BROVGHTON
PRIMI
BARONIS FAIRHAVEN
CENTESIMO ANNO ANTE
NATI QVIPPE QVI HORTOS
HOSCE OLIM ABBATIAE
ANGLESIAE DISPOSVIT
MCMXCVI

This small enclosure at Anglesey Abbey, Cambridgeshire, houses a statue bordered by *Stipa arundinacea* grass and an *Elaeagnus macrophylla* hedge.

WRITERS'
RETREATS

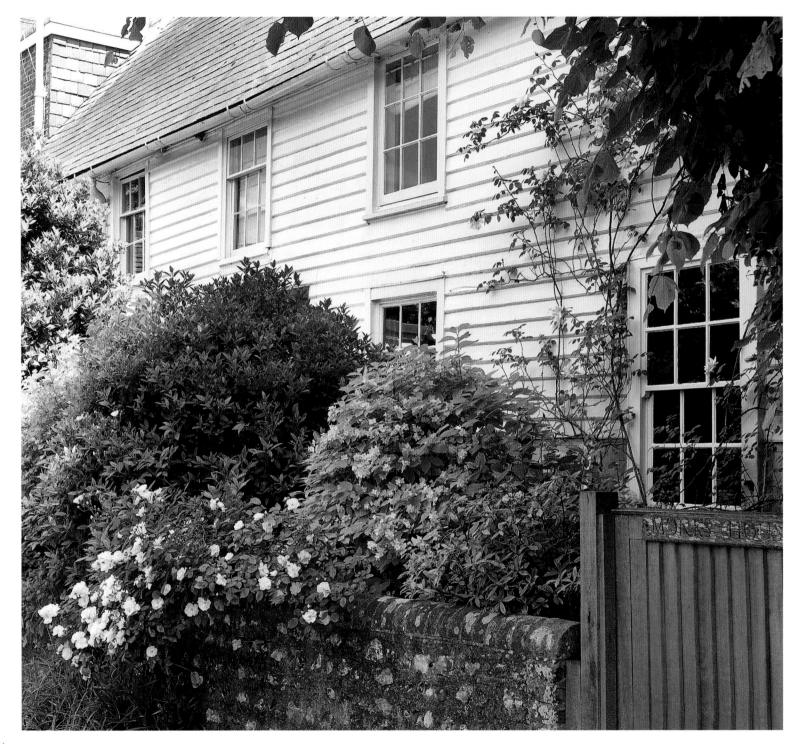

MONK'S HOUSE, EAST SUSSEX

LEFT The house barely has a front garden; its horticultural riches are hidden from sight and come as a delightful surprise. Leonard Woolf commissioned the simple gate on the right to look deliberately plain.

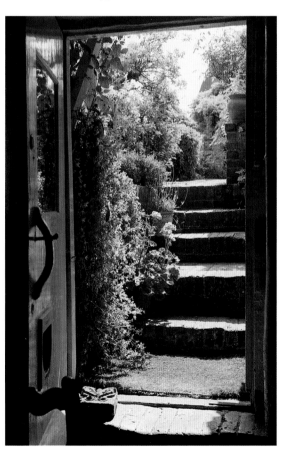

The garden at Monk's House radiates a quiet beauty that reflects the personalities of its former owners, Virginia and Leonard Woolf. While at nearby Sissinghurst Virginia's one-time lover and close friend Vita Sackville-West was creating what would become one of England's most idolised gardens, the Woolfs were shaping their own little Eden. Sissinghurst is self-assured and dazzling. Monk's House is understated and introspective – and all the more bewitching for it.

Throughout her adult life, Virginia Woolf suffered bouts of debilitating depression. Her small country home, with its gently enveloping garden, was her refuge, far enough away from London's social bustle to restore her frayed nerves. At Monk's House she enjoyed 'snatches of divine loneliness'. Crucially, it was here that she did most of her writing. Every morning, 'with the regularity of a stockbroker', she would make her way out of the house to her writing lodge in the garden: '[Tomorrow I] shall smell a red rose, shall gently surge across the lawn, light a cigarette, take my writing board on my knee; and let myself down, like a diver, very cautiously into the last sentence I wrote yesterday.'

Proudly announcing her acquisition of Monk's House to a friend in 1919, Virginia Woolf wrote: 'The point of it is the garden… This is going to be the pride of our hearts; I warn you.' She was right; her husband Leonard became obsessed by his ¾-acre plot. He designed it, planted it and kept adding to it for the rest of his life. Virginia enjoyed assisting him. Like walking, which she loved, gardening was the ideal counterpoint to hours spent crouched over a desk. One day she recalled 'weeding all day to finish the beds in a queer sort of enthusiasm which made me say this is happiness'.

Secluded at the end of a lane in the village of Rodmell in East Sussex, Monk's House hides its charms well. The plain white weatherboard building gives away none of the delights to come. First glimpses of the garden are misleading too. Shady, formal and minimal in its planting, the small Italian Garden is unlike any of the other areas at Monk's House. Leonard Woolf created this quiet spot inspired by a holiday in Tuscany.

LEFT The sun-drenched view from the kitchen offers a glimpse of the garden.

Virginia, practical and money-conscious as she was, bought the Italian-looking pots from a grocer's shop in nearby Barcombe. The effect is simple but evocative.

Leonard Woolf was a passionate plantsman, so it seemed only natural to attach a conservatory to the house in which to grow tender plants. He added it in the 1950s, after Virginia's death, but prior to this he kept three heated greenhouses in the garden, one of which was designed just for growing cacti. Virginia called them his Crystal Palaces. Today the conservatory is still home to exotic and Mediterranean plants, such as daturas, clerodendrums and crinums.

From the conservatory, a thread of narrow brick paths beckons you into the flower garden. Small enclosures – each with its own identity – offer, from spring to late autumn, a floral welcome. In the height of the summer the paths overflow with blooms and foliage, so that you find yourself snaking through lush growth, drawn to from one delight to the next.

'Our garden is a perfect variegated chintz: asters, zinnias, geums, nasturtiums & so on: all bright, cut from coloured papers, stiff, upstanding as flowers should be,' Virginia wrote. The garden cast a spell on her; its beauty stimulated lyrical descriptions. Leonard was fond of bright, exotic colours, perhaps because he had lived in Ceylon in his twenties. His favourite flowers – zinnias, dahlias, kniphofias and roses – offered him a palette of strong hues with which to paint. But, ever the plantsman, he also liked white flowers, such as lilies and Japanese anemones.

There is a delicacy to the planting, partly due to the fact that Leonard rarely planted in clumps. He bought flowers for their individual qualities and positioned one next to another, creating – at times subtle, at times electric – combinations. Today's garden offers striking juxtapositions of deep purples and bright oranges, blues and reds, lilac blues and burnt oranges. At other times, pastel arrangements of lavender blues and pale pinks and purples create a more romantic effect.

Leonard laid many of the paths by hand; Virginia sometimes helped, thinking it 'rather fun'. When the couple bought Monk's House, the garden featured a few small, crumbling buildings, including an old laundry and earth closet. These were soon torn down, but

Taken from the balcony of Leonard's attic study, this vista shows the dense planting of the flower garden with its network of brick paths and old walls. Virginia's writing lodge is visible in the middle ground, while the spire of St Peter's Church and the gently rolling South Downs act as a suitable pastoral backdrop.

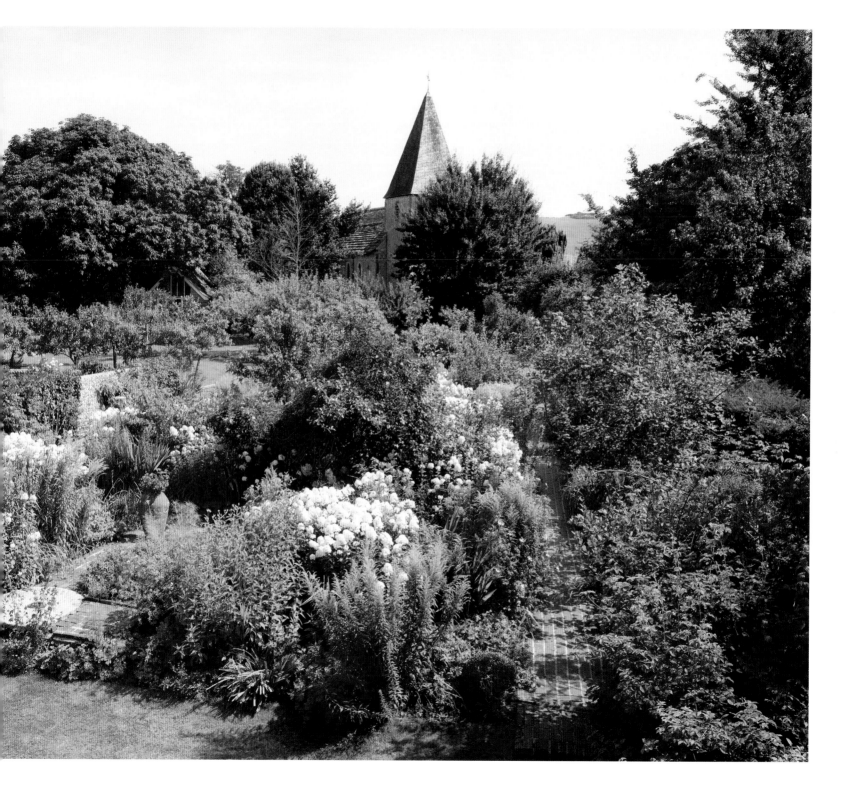

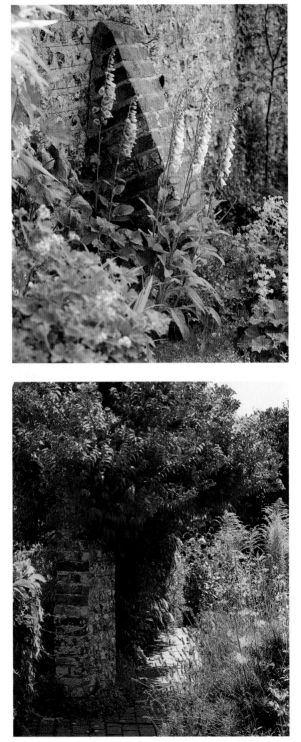

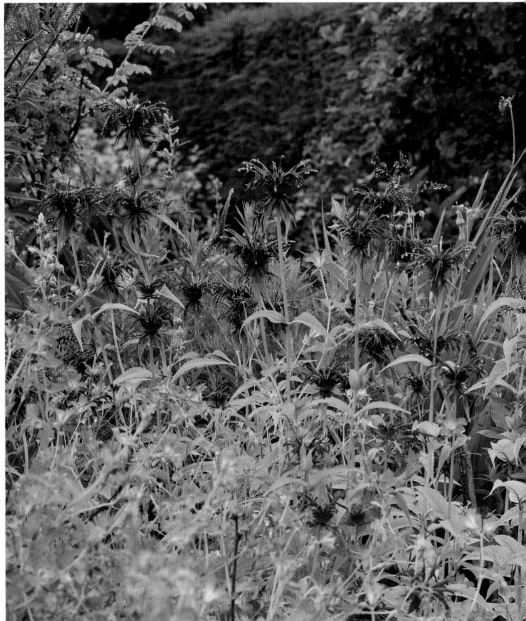

TOP LEFT Self-seeded foxgloves, *Alchemilla mollis* and pelargonium 'Attar of Roses' nestle against the old granary wall. BOTTOM LEFT In high summer, the Chinese trumpet vine, *Campsis grandiflora*, produces an explosion of fiery blooms.

ABOVE The striking, tufted blooms of *Monarda* 'Cambridge Scarlet' are framed by a pink-and-white cranesbill geranium and *Campanula trachelium*.

This tapestry of flowers combines bright-yellow lysimachia, lavender-coloured *Salvia* x *sylvestris* 'Mainacht', verbascums and roses.

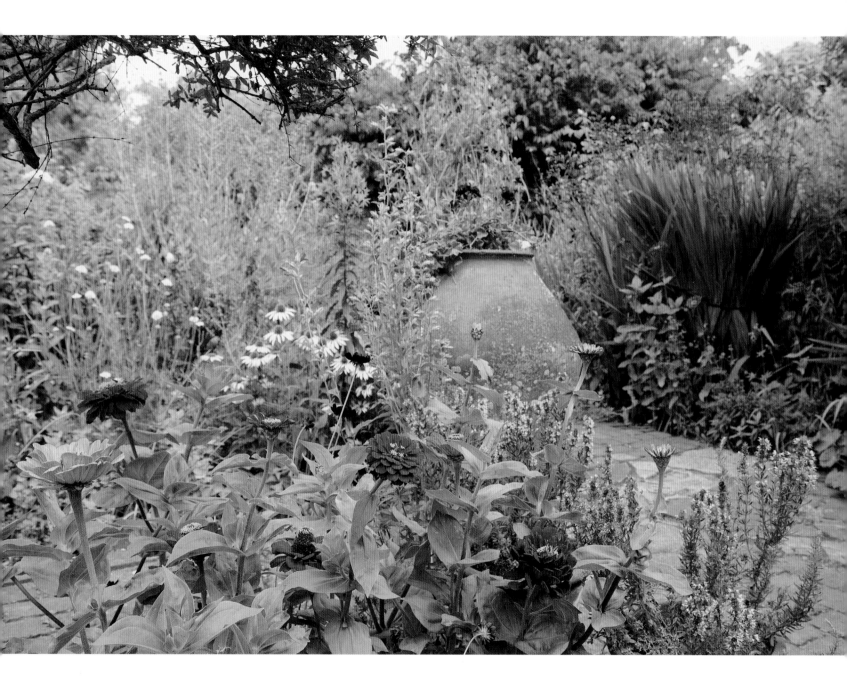

The Millstone Terrace bursts into colour in summer with zinnias, crocosmias, *Perovskia* 'Blue Spire', campanulas and echinaceas.

RIGHT A white rose scrambles up the house in summer. Leonard Woolf added the lean-to conservatory in the 1950s so that he could indulge his passion for exotics.

BELOW RIGHT Pink and purple dahlias in the late summer.

BELOW CENTRE The opulent and velvety rose 'Charles de Mills' in the garden in July.

BELOW LEFT A Peacock butterfly is drawn to the michaelmas daisies in September.

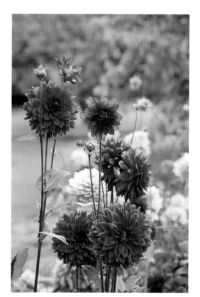

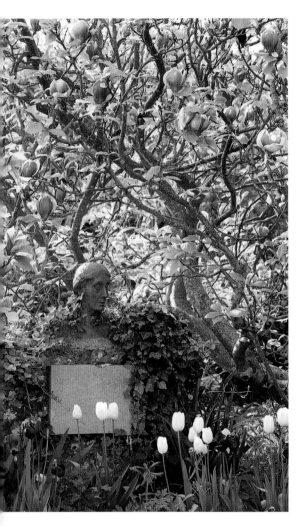

Leonard kept the wall of an old granary, which, along with established trees, provided the perfect support for wisterias, roses and clematis. He added other structural elements too. He built three ponds and the couple delighted in gazing at the fish. He bought large terracotta vases and filled them with trailing red geraniums, creating visual exclamation marks. He recycled old millstones and cobbles into yet more paths.

The informal, often dense planting coupled with structural divisions and focal points offer ample opportunities to pause and contemplate or, in the case of the ponds, to succumb to deep introspection. This is fitting for the garden of two great thinkers. Some spaces also reflect the Bloomsbury Group ethos, with its regard for close friendships, conversation and fun. As the garden opens up, wider, more social, areas reveal themselves. The orchard, possibly Virginia's favourite part of the garden, 'is the very place to sit and talk for hours'. On the terrace by her writing lodge, guests would gather and sit in deckchairs, soaking in the views of the water meadows and the South Downs, or play bowls on the lawn.

Despite its visual allure, there was another point to the garden: the production of fruit and vegetables. The kitchen garden was as big as the flower garden, and there was the orchard to look after, as well as beehives. Leonard eventually had to employ a full-time gardener to keep it all going. Virginia played her part her too, bottling the fruit and the honey and pickling the beans. Leonard enjoyed sharing his garden's bounty with friends, while the surplus was sold at the local Women's Institute market.

Like Sissinghurst, this was a garden shared by a couple. Leonard was the creator; Virginia the sporadic assistant but constant admirer. Virginia once asked: 'What do you think is probably the happiest moment in one's whole life?' She answered the question herself: 'I think it's the moment when one is walking in one's garden, perhaps picking off a few dead flowers, and then suddenly one thinks: My husband lives in that house – and he loves me.' There is no doubt that Leonard and Virginia Woolf's garden helped nurture their relationship.

Virginia hated this bust of her, created by Stephen Tomlin in 1931. Her nephew, Quentin Bell, remarked: 'Somehow Virginia managed to forget, in agreeing to the proposal, that the sculptor must inevitably wish to look at his sitter and Virginia should have recollected that one of the things she most disliked in life was being peered at.'

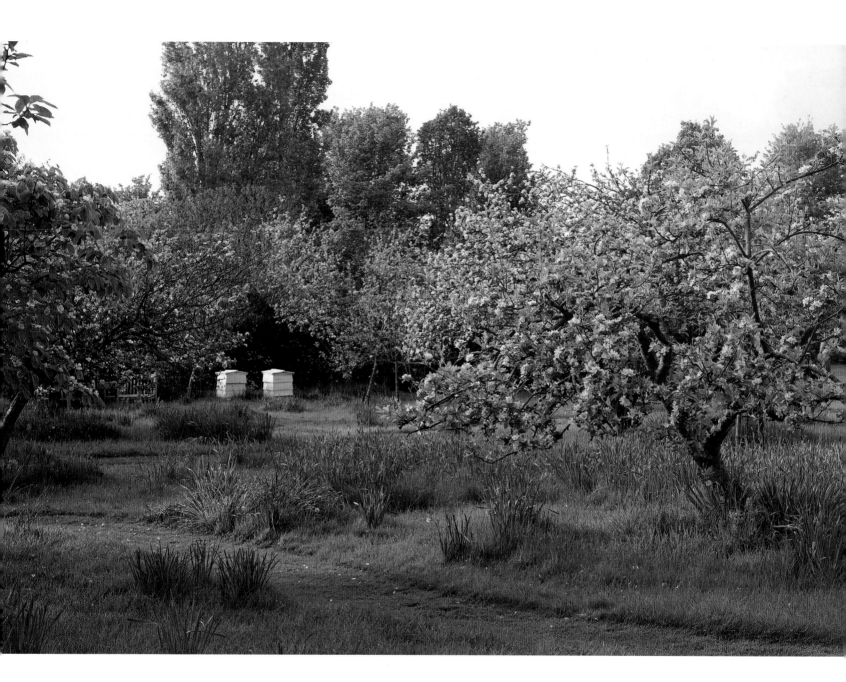

The orchard in bloom. One of Virginia's favourite parts of the garden, it probably inspired her short story, 'In the Orchard'.

HILL TOP, CUMBRIA

'I wonder whether I shall do any sketching, or waste all my time gardening,' Beatrix Potter wrote to a friend in 1906. The author-illustrator had recently acquired Hill Top, a seventeenth-century farmhouse in the picturesque Lakeland village of Near Sawrey. Her new garden did, indeed, prove a distraction from her artistic pursuits, but it would also become a source of solace and inspiration.

A few months before acquiring Hill Top, Potter had lost her fiancé, the publisher Norman Warne. Heartbroken, she threw herself into creating a comforting blanket of a house and garden. She filled the cosy interiors with old oak furniture and cherished heirlooms. She made a garden that would become a haven of peace and uplifting beauty. For the rest of her life – even though she never lived there full-time – Hill Top would be her refuge.

Inspired by its simple charms, Potter's first years at Hill Top were her most creative. The house and small garden, and indeed the village itself, became backdrops for many of her well-loved characters: Jemima Puddle-Duck, Tom Kitten, Samuel Whiskers and others. Potter delighted in re-creating her surroundings and those who visit Hill Top today often feel it to be oddly familiar. Here is the long flower-edged path where the affronted Mrs Tabitha Twitchit led naughty Tom Kitten to the house. Here too is the little white gate and moss-covered stone wall on which Tom, Moppet and Mittens watched the Puddle-Ducks waddle past. And here in the vegetable garden is the rhubarb patch where Jemima tried to hide her eggs.

Published in 1902, *The Tale of Peter Rabbit*, the first of her little books, had brought Beatrix Potter money and fame. The latter she did not care for, but the former meant independence, which she craved, having suffered a stifling middle-class upbringing in London. Potter, a country mouse at heart, loved the freedom and beauty of wide-open spaces, delighting as much in the detail of individual plants and animals as in the open vistas of Scotland and the Lake District, where she spent long family holidays.

The classic view of the garden at Hill Top, as seen when you walk up the path to the house.

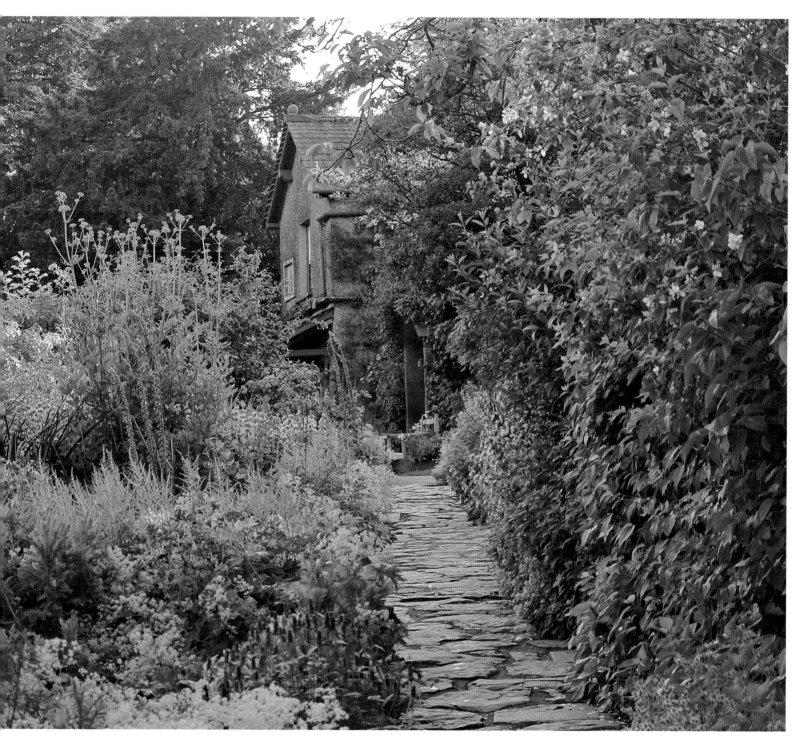

TOP LEFT The view from the meadow to the craggy landscape beyond. LEFT In high summer the trellis is draped in old-fashioned roses in shades of white, pink and purple. ABOVE Lysimachias, campanulas, pink meadowsweets and Shasta daisies in the main borders in June.

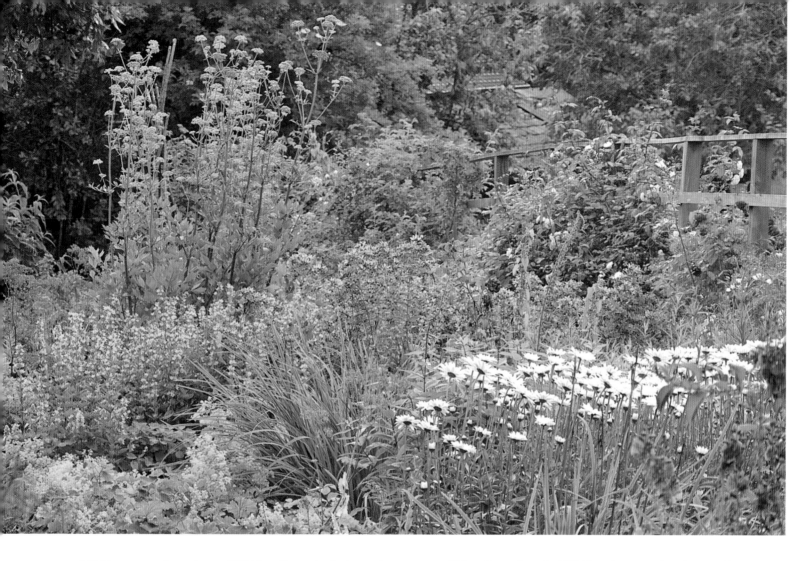

Within a year of moving to Hill Top, Potter had planned and executed the layout of her half-acre plot. Today it still reflects her higgledy-piggledy style of gardening and love of old-fashioned plants such as roses, honesty, hollyhocks, saxifrage and phlox. Much like Beatrix Potter herself, the garden is utterly unpretentious. Fruit bushes and vegetables grow next to herbaceous perennials and shrubs in a pleasing blend of the practical and the beautiful. Informality and the happy accidents of nature are what appealed to her most.

When Potter bought Hill Top there was barely a garden to speak of – only a small kitchen garden opposite the front door, separated from the house by a farm track. To increase the garden space, she moved the track away from the house. She added the now iconic slate path that leads to the house and built a long wall to separate the garden from the Tower Bank Arms next door.

Her new garden focused on four areas: the old kitchen garden, a large paddock, a small orchard and deep, long borders either side of the new path. Walls and edgings were created using local

ABOVE This little scene in the vegetable garden is reminiscent of *The Tale of Peter Rabbit*.

materials, in keeping with the contemporary Arts and Crafts ethos. At the back of the border adjoining the orchard, Potter added a long trellis and by the summer of 1906 the beds were ready for planting. Neighbours were more than happy to help. 'I am inundated with offers of plants,' she wrote in September 1906.

Over the years, the garden evolved as much by chance as by careful planning. Potter encouraged self-seeders, such as Welsh poppies, foxgloves and columbines, to grow where they pleased. She let plants such as ferns and houseleeks appear in cracks in the walls. This was cottage gardening at its most liberated.

When the National Trust started restoring the garden in the 1980s, little remained of Potter's original planting. Photos taken by her father, her correspondence and the illustrations in her books were important sources of information for the team at Hill Top.

Much like the garden's original creation, the restoration didn't follow a strict masterplan; it developed over time, making it all the more authentic – both in spirit and appearance.

For Pete Tasker, Hill Top's gardener for over 25 years, Rupert Potter's photos are crucial in understanding the range of plants that his daughter grew. 'Our aim is to make the garden look as it did when Beatrix Potter lived here,' he explains. 'No plant is sourced that was not around in her time. Today about 90 per cent of the plants in the garden are historically accurate.' If you spot the occasional weed or untidy shrub, this is because Pete is staying true to the cottage style that Potter embraced.

The long beds are filled with a pleasing mix of cottage garden plants. In spring, lady's mantle (*Alchemilla mollis*) reveals its fan-shaped apple-green leaves, while irises, columbines, forget-me-nots, hardy geraniums and honesty come into flower. In summer, yellow loosestrife, soapwort (*Saponaria officinalis*), meadowsweet (*Astilbe*), acanthus, phlox and Shasta daisy (*Leucanthemum superbum*) happily mingle with roses, gooseberries, beans and wigwams of sweet peas. Autumn brings a warm show of Michaelmas daisies, Japanese anemones, rose hips and pumpkins. The delicate seed-heads of honesty and other perennials are an attractive sight throughout the winter.

In spring the house is draped in the pale pink *Clematis montana* 'Elizabeth', shortly followed by the heady-scented *Wisteria sinensis* 'Alba'. A climbing rose (possibly 'Madame Isaac Pereire') with large deep pink blooms and the pale blue *Clematis* 'Perle d'Azur'

A rustic door set into a slate wall leads into Beatrix Potter's vegetable garden.

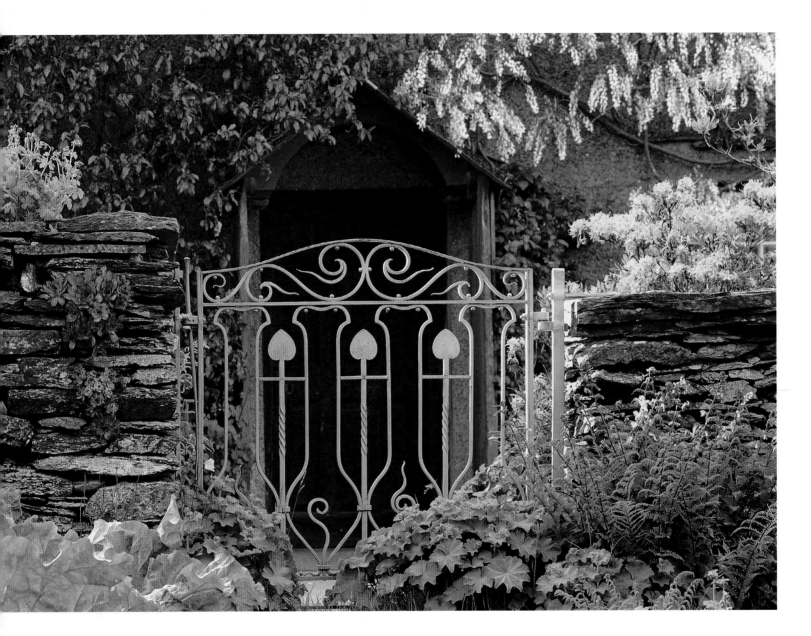

Lady's mantle (*Alchemilla mollis*) and ferns happily grow against the slate wall that divides the front of the house from the vegetable garden.

Columbines (*Aquilegia vulgaris*) and *Iris sibirica* in the garden in June.

FAR RIGHT In May the house is draped in sweet-smelling Chinese wisteria (*Wisteria sinensis* 'Alba').

take centre stage during the summer months, while the yellow-flowered St John's wort nestles up against the house.

The little green gate opposite the house looks onto Potter's beloved vegetable garden. Here, despite the slightly acid soil and the wet weather, four beds produce peas, potatoes, radishes, cabbages and lettuce, as well as raspberries, gooseberries and strawberries. A wooden beehive sits in the bee bole, exactly as it did in her time, and tools are arranged among the vegetables in homage to Mr McGregor.

Beatrix Potter married local solicitor William Heelis in 1913. She had spent so much time making Hill Top her own that, rather than make her husband adjust to it, she created a new marital home over the road at Castle Cottage. Her career took a change of turn, too. She wrote less and became an expert farmer and sheep-breeder. She became passionate about conservation, using the royalties from her books to buy farms and land that were under threat of development, and collaborated with the National Trust to preserve Lake District land. Throughout her life Potter's affection for the natural world was all-important – the common thread linking her many incarnations.

131

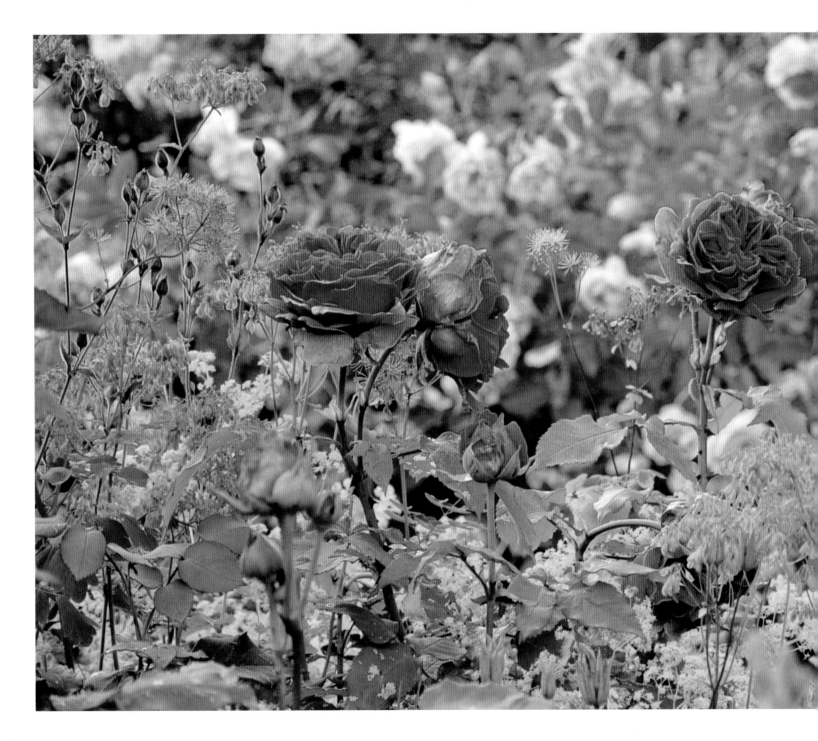

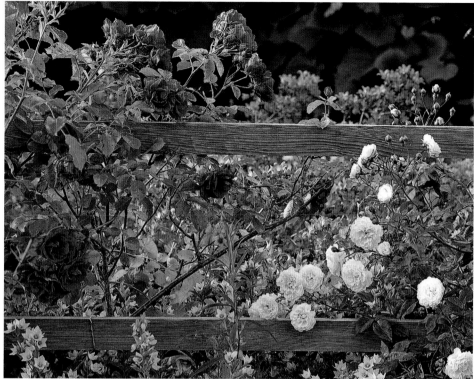

Looking out onto her Hill Top garden one February, Potter admired the snowdrops: 'There are thousands in front of the windows and in the orchard and in the lawn. This is why I have an untidy garden. I won't have the dear things dug up in summer, they are so much prettier growing in natural clumps, instead of being dried off and planted singly.' Perhaps it is in this unassuming little garden, charmingly tangled in places and left to its natural inclinations in others, that Beatrix Potter's love of nature shines most brightly.

ABOVE The rustic rose-clad trellis is underplanted with yellow lysimachia.

LEFT *Rosa* 'Madame de la Roche-Lambert' and *Alchemilla mollis* with light pink Rosa 'Felicia' in the background.

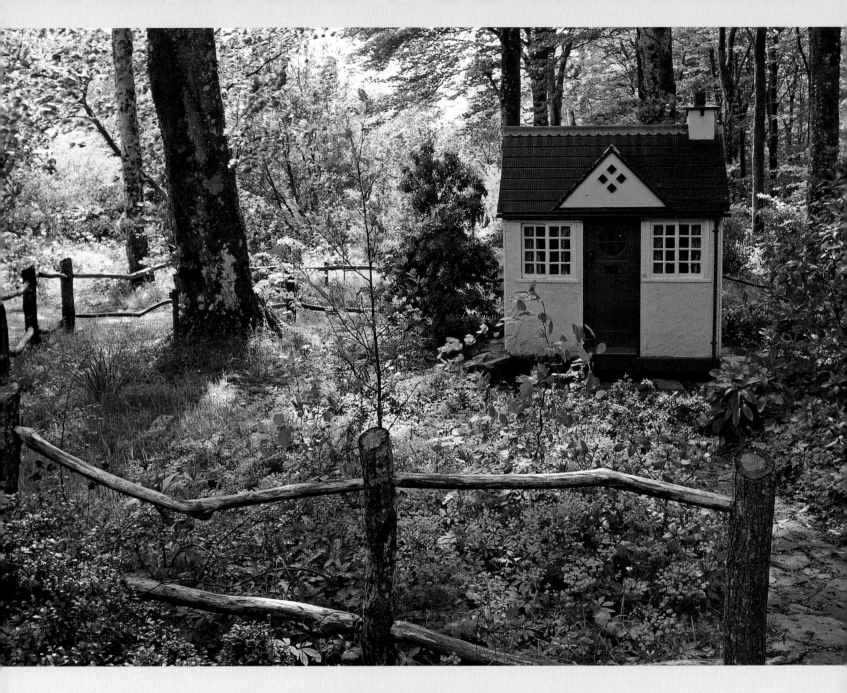

Julius Drewe, who commissioned Castle Drogo in Devon, built this playhouse for his daughter Frances in a secluded part of garden. Known as the Bunty House, it even has its own miniature cottage garden.

Childhood Haunts

There is a memorable scene in *The Secret Garden* by Frances Hodgson Burnett, when ten-year-old Mary Lennox unlocks the door to a mysterious walled garden, which has lain hidden for years. Everywhere is a tangle of wilderness. Trees are thick with climbing roses. Young growth hides amongst the long grass. Mary feels 'excitement, and wonder, and delight… She seemed a million miles away from anyone, but somehow she didn't feel lonely at all.'

For many of us, childhood experiences of gardens bring back similar feelings of discovery, freedom and adventure. Drawn to less formal, out-of-the-way corners such as orchards, meadows and woodlands, children feel free to run and play, make dens, spot bugs and search for butterflies.

A summerhouse, Wendy house or boathouse is a world of make believe waiting to happen. Topiary is an opportunity for a game of hide-and-seek. Paths, tunnels and mazes lead to adventure. A bridge means a game of Poohsticks.

On the edge of the Cotswolds and commanding beautiful views, Newark Park in Gloucestershire boasts acres of dense woodland, perfect for a day of exploring.

The Dodo Terrace at Mount Stewart in County Down, Northern Ireland, is a fairyland of weird and wonderful statues that will capture the imagination of children and adults alike.

Cornish valley gardens often feel hidden and untamed – qualities which make them particularly appealing to children. At Glendurgan Garden, the sense of excitement and discovery is heightened by a wonderful cherry laurel maze.

Built in a quirky Swiss-chalet style, the Boathouse at Belton, Lincolnshire, was used by the Brownlow family for picnics and as a base from which to enjoy their estate.

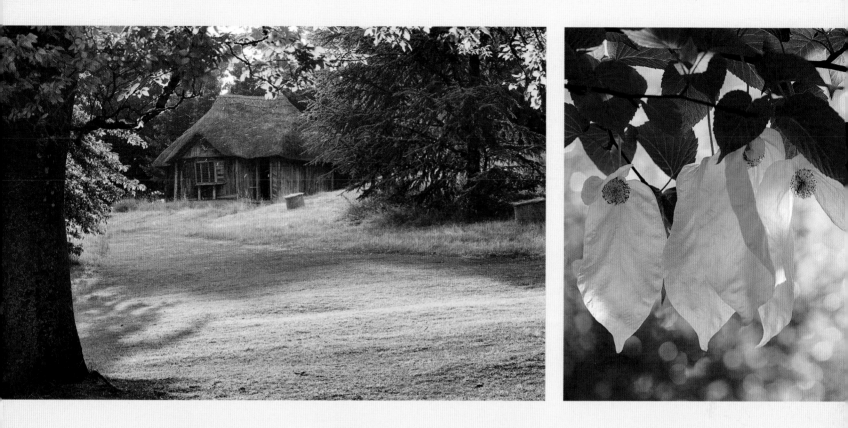

ABOVE The Bear's Hut at Killerton, Devon, was once used to house a 'pet' black bear called Tom.

ABOVE RIGHT In July, the bracts of *Davidia involucrata* at Nymans, Sussex, look like little white handkerchiefs hanging off the trees.

Children are particularly alive to the wonders of nature: bark that you can peel off, flowers that smell of chocolate, leaves that look like handkerchiefs. But the very best gardens return us all to this childlike state of awe. Immersing us in their manifold beauties, they transport us far away from our worries and cares.

Visitors looking at the blossom from a bridge at Stagshaw Gardens, Cumbria.

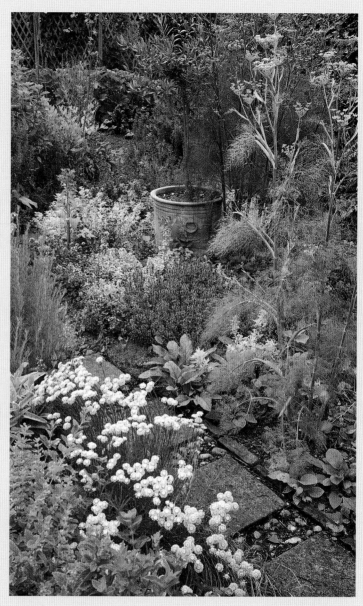

TOP Among the bluebells at Chartwell, Kent.

ABOVE Painted lady butterflies feed on red valerian (*Centranthus ruber*) at Trelissick Garden, Cornwall, in June.

ABOVE In July, the Herb Garden at Lamb House, East Sussex, features a pretty combination of santolina, lavender, thyme, rosemary and fennel; children love discovering the scents of all the different herbs.

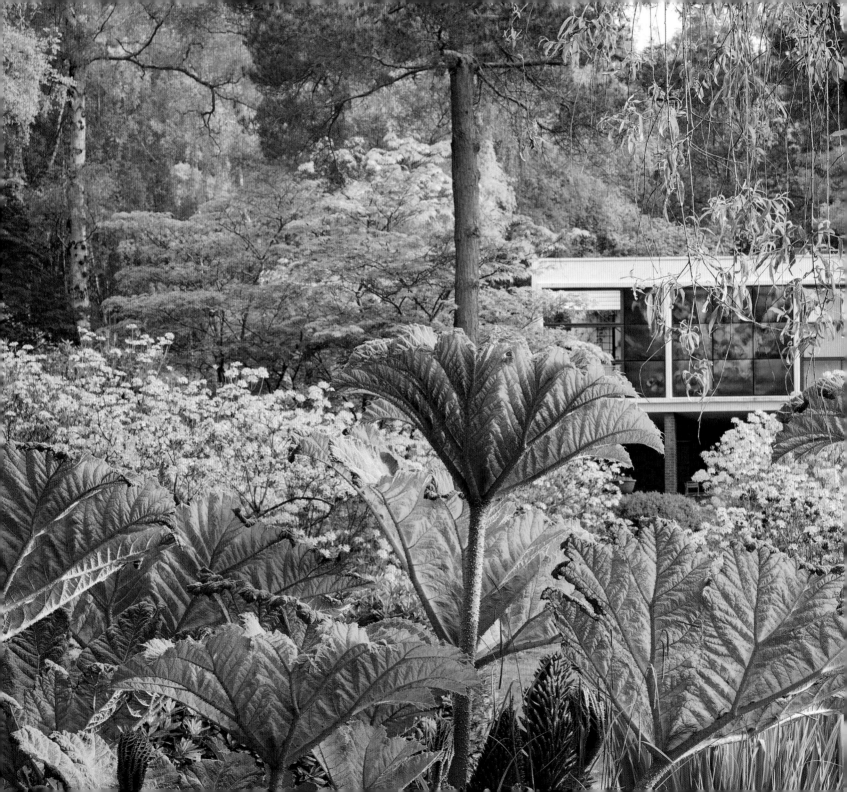

Modern Masterpieces

THE HOMEWOOD, SURREY

'I badgered them and sold them my ideas from breakfast to dinner.' At the tender age of 24, newly trained architect Patrick Gwynne persuaded his parents to let him build a radical Modernist house in their garden. The year was 1937. Gwynne had lived with his family at Homewood, a large Victorian house on the edge of Esher Common in Surrey, since babyhood. Soon he, his parents and sister would swap their old-world cosiness for a bright, cutting-edge home. Gwynne called it The Homewood; the definite article adding weight and dignity – not that it needed it – to his new creation.

By July 1938 the house was complete and the family celebrated with a party. 'We danced like mad,' Gwynne recalled. The sprung floor came in handy. So too did the gramophone, drinks cabinet and bar, each ingeniously hidden in the Living Room wall. In the Dining Room, Gwynne inserted a home cinema and the obligatory grand piano.

Influenced in part by Le Corbusier, a pioneer of Modernist architecture, Gwynne created a home that had all the ingredients of the new style: a horizontal, block-like structure, supporting columns (known as pilotis), a white-rendered exterior, flat roof and large windows. He spared no expense and considered every detail. His father came to call it 'the temple of costly experience'. Building it cost £10,500; houses in the area were selling for £400 at the time. Gwynne ended up living there for the rest of his life, establishing a small but successful architectural practice. The Homewood was 'the great love of Patrick's life', his architect friend Denys Lasdun noted. Over the decades Gwynne refined the house, keeping it fashionably up-to-date.

Despite all its contemporariness, The Homewood was rooted in a classical ideal: a rigorous system of proportion that reflected Gwynne's perfectionist aesthetic. Interior and exterior were designed as a harmonious whole. So too was the garden, which Gwynne started developing in the 1960s. It is not by chance that the house is south-facing and in a slightly elevated position, or that all the main rooms are on the first floor, with large windows taking full advantage of the views.

PREVIOUS PAGE Giant rhubarb rises from the water at The Homewood, creating a dramatic foreground in this most painterly of gardens.

RIGHT Large reflections add to the beauty of the garden.

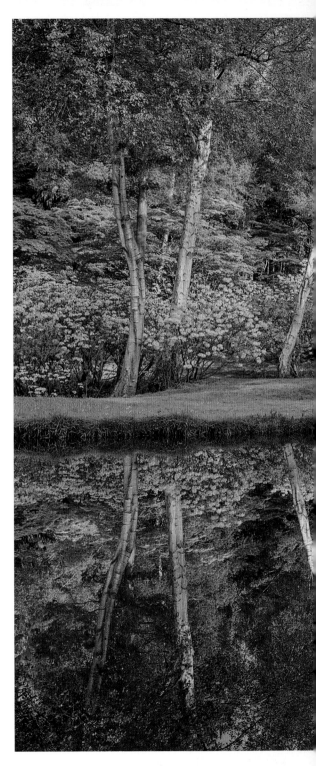

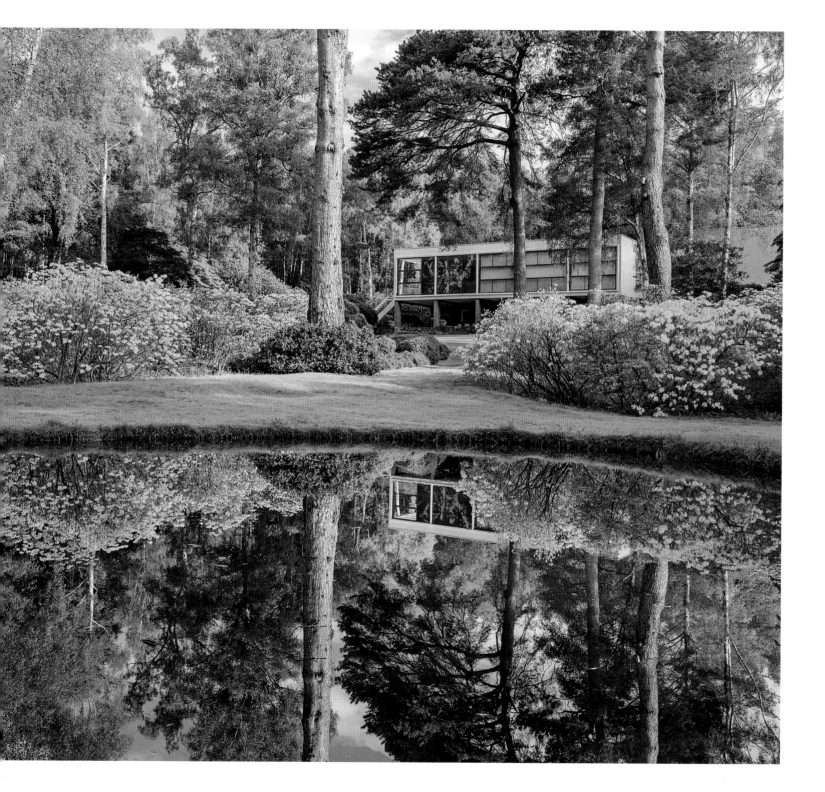

The garden in early spring. Its many trees and shrubs offer an ever-changing tapestry of colours.

The garden may look naturalistic, shaped as it is by the surrounding Surrey heathland, but what you see is actually a series of carefully orchestrated set-pieces. Like the master of landscape gardening 'Capability' Brown, Gwynne altered water features, took away trees and planted new ones, and added focal points to create a sophisticated, painterly garden. Also, as in the eighteenth-century landscape park, the formality of the house balances the contrived naturalism of the garden.

The slightly sloping, 4-hectare (10-acre) garden is bisected by a stream, from which Gwynne created a series of water gardens. He celebrated local plants such as heathers, pines, oaks and birches, while adding touches of brilliance in the form of acers, azaleas and species rhododendrons. Here too, his design approach was rational, based on three horizontal tiers: heathers and azaleas at ground level, rhododendrons or laurels in the middle, and soaring trees above.

The Living Room features a dramatic wall of glass, offering a raised view down the length of the garden.

Within this simple framework, there is, however, lots of detail. The Heather Garden is not just planted with local heathers (*Calluna vulgaris* was actually gathered directly from the common), but features a range of species – including late winter and spring-flowering *Erica erigena* and *Erica arborea* and autumn-blooming *Daboecia cantabrica* – offering a delicate palette of pinks, purples and whites. The Japanese maples (*Acer palmatum*), which take centre-stage in autumn, produce a rich tapestry of shades, from bright reds and greens, to burnt oranges, pale yellows and warm toffees.

David Scott, who has lived here as a tenant with his family since 2007, appreciates Gwynne's talent. 'There's a lot about the eye-catcher and the long view here,' he says. 'The idea is that you don't reveal everything. The garden is a series of little crescendos.' The first of these comes early. As you approach The Homewood, the drive curves suddenly, presenting you with a first glimpse of the house, then it quickly disappears. When you see it again, it is a completely different house. Scott describes this as Gwynne's love of 'conscious disorientation and playfulness'. Like all artists, Gwynne was master of his creation. He planned it carefully, naming each of the key areas.

Arriving at the house, the Rhododendron Tunnel leads the eye towards a concrete bench in the distance – the first of Gwynne's eye-catchers. Walking through the darkness, you emerge into the small Grey and Yellow Garden. Yellow waterlilies (*Nymphaea lutea*) fill a concrete planter pond. Surrounding it, hostas, epimediums, euphorbias, santolinas, hellebores, potentillas, sedums, *Kniphofia* 'Percy's Pride' and *Alchemilla mollis* each play a part in a subtle tonal mix of fresh greens, grey-greens, soft greys, and pale and butter yellows.

The garden slopes towards the water, whose features become more naturalistic the further you descend. On the main pond is a Monet-inspired concrete bridge. Further down, square stepping

The view from the stepping stones towards the house, with yellow flag iris (*Iris pseudacorus*) just starting to flower in the pond.

An untidy row of small birches lines the water's edge near the Main Pond.

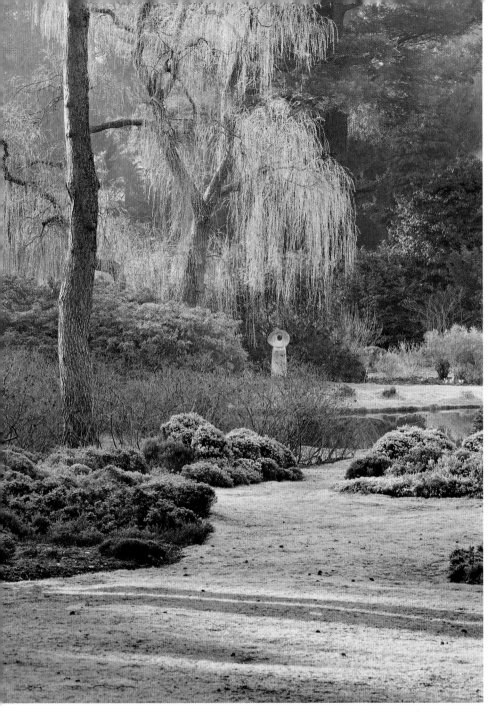

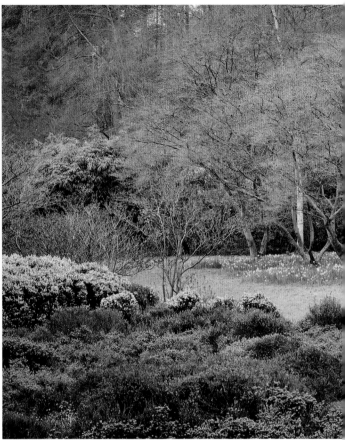

ABOVE In spring, when many of the deciduous trees have yet to bear leaves, the garden is enlivened with white, pink and purple heathers.

LEFT The view over the main pond, where a graceful willow shelters a Portland stone sculpture, *Eclipse* (1999), by Bridget McCrum.

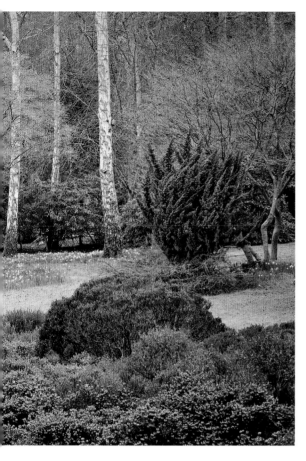

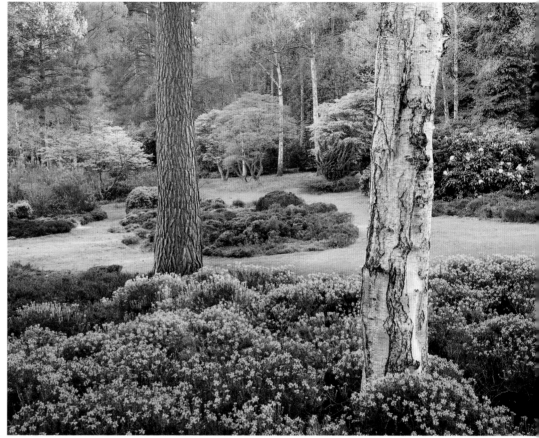

TOP RIGHT A sea of yellow provides the perfect colour complement to the purple heathers.

stones hover gracefully over the water. Next, a series of tiny cascades add sound and movement to the experience. Finally, a Bog Garden spreads out, with giant rhubarb (*Gunnera manicata*) dwarfing dashes of hostas, hemerocallis and candelabra primulas. Looking back at the house, you realise that the garden is enhanced by reflections: water and windows mirror the moods of the sky and movements of the trees, in an ever-shifting, cinematic effect. The house looks as if it is floating, its weightless first-floor capsule gliding above the shrubs.

Over the water, in the Bamboo and Fern Thicket, Scott has introduced small glades, creating 'little magical glimpses' towards the bog garden and the house. Tucked away, almost hidden from view, the Blue and White Garden comes as a delightful surprise. Within his majestic woodland, it seems Gwynne needed a small reminder of a traditional

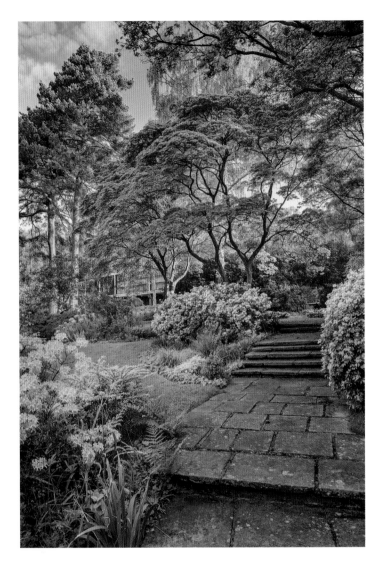

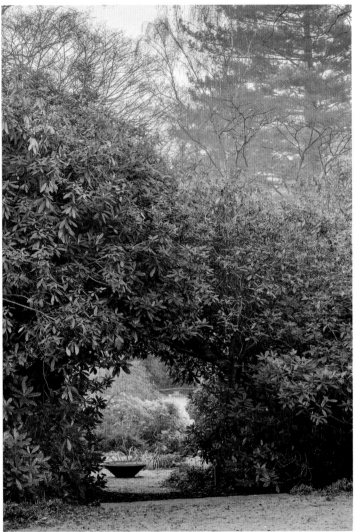

The gentle rise of York stone steps leads you to the Grey and Yellow Garden and offers one of the loveliest views of the house amongst trees and shrubs.

Looking through the Rhododendron Tunnel towards the Yellow and Grey Garden with its small planter pond.

RIGHT The Grey and Yellow Garden is a small space marked by a pattern of herringbone brick paving with a planter pond in the centre.

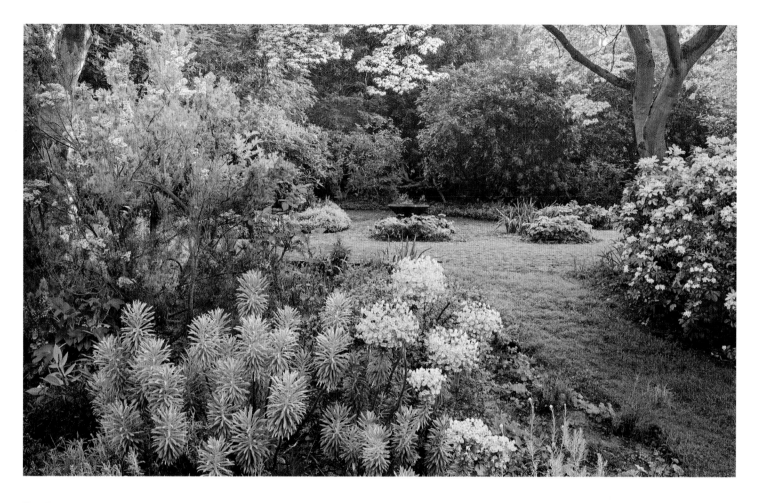

English garden. Herbaceous beds offer a long floral display: spring-flowering forget-me-nots, grape hyacinths and ceanothus are followed by white grandiflora and blue lace-cap hydrangeas, white hebes and cosmos in the summer and autumn. Nearby, a metal arbour is cloaked in white roses – 'Iceberg', 'Madame Alfred Carrière' and 'Snow Goose'.

Walking round the garden, you are immersed in its scents and sounds, its topography and microclimates. The experience is one of repeated discovery and revelation. Viewed from the first-floor Living Room, the garden takes on a different character. The vast windows frame a dramatic two-dimensional tableau of Japanese influence. Shadows, shapes and colours come into broader focus, and a bigger, almost static picture is brought to light. Here is where Gwynne's mastery is fully revealed; inside and out, house and garden are consonant partners in this total work of art.

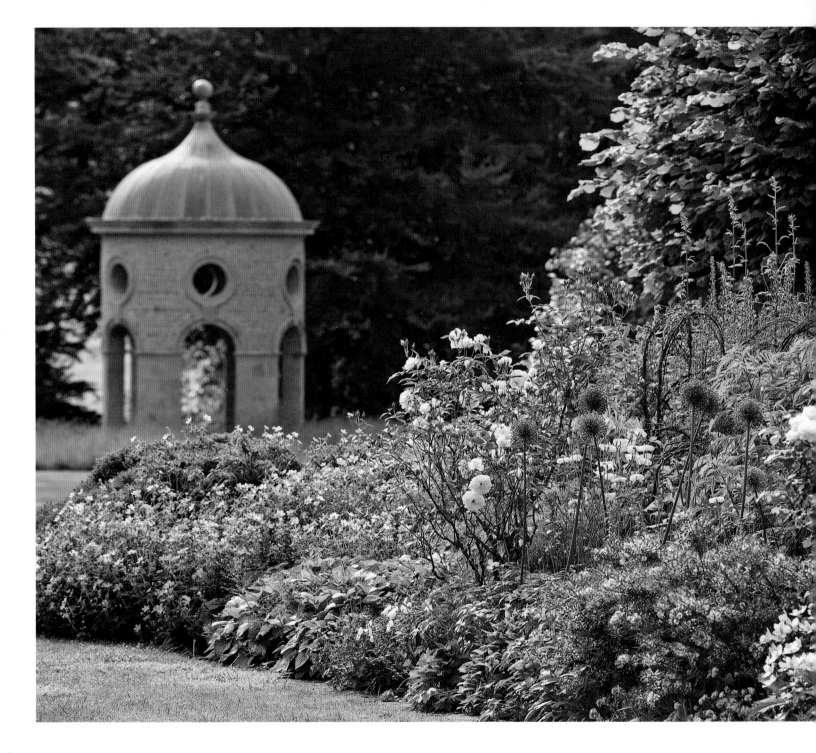

WOOLBEDING, WEST SUSSEX

When Prime Minister Benjamin Disraeli visited Woolbeding in the 1840s, he called it 'the loveliest valley in the land'. Today this rural Arcadia is home to a contemporary garden so secret that many locals don't even know it exists.

Why has Woolbeding remained so little known? For a start, the garden only opened to the public in 2011, but it was also the home of a very private couple. Inspired by a love of art, garden history and plants, Simon Sainsbury and Stewart Grimshaw spent four decades quietly shaping the land around the River Rother valley. They created a garden of outstanding virtuosity, so organically grounded in its surroundings that it feels as though it has been there for far longer than its years.

Simon Sainsbury, who died in 2006, was the great-grandson of grocer John James Sainsbury, founder of the famous supermarket chain. As Finance Director, he led the public flotation of the company, at that time the largest in the Stock Exchange history. He was also a passionate art collector and philanthropist. Stewart Grimshaw, a bookseller by trade and botanist by training, still lives at Woolbeding and continues to develop the garden with head gardener Paul Gallivan.

Sainsbury's and Grimshaw's artistic leanings and horticultural erudition shine through in their creation, which blends the best of gardening styles. Herbaceous borders recall the late Victorian heyday of the English country-house garden. Avenues of pleached limes, neat topiary and sharp lawns are formal nods to France and Italy, while the English Landscape Movement is celebrated in the wildest and remotest part of the garden.

The house and estate came into the hands of the National Trust in 1958. With no legacy to restore or maintain it, the Trust offered it on long-term lease, hoping a benevolent tenant would look after it. What Sainsbury and Grimshaw achieved was beyond all expectation. The manor house was damp and bug-infested when they signed the lease in 1972. Two years of painstaking restoration saw it rise again.

LEFT One of the West Borders, with *Rosa* 'Iceberg', *Allium hollandicum* 'Purple Sensation' and *Geranium* 'Blue Cloud'. The building in the distance is the Tulip Folly; it commemorates a tulip tree that fell in the great storm of 1987.

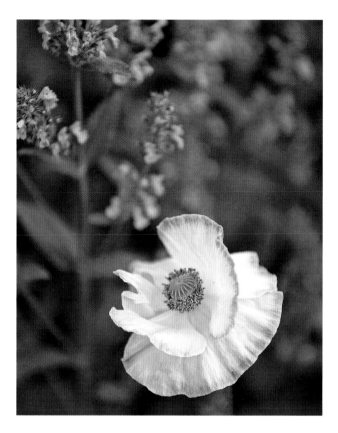

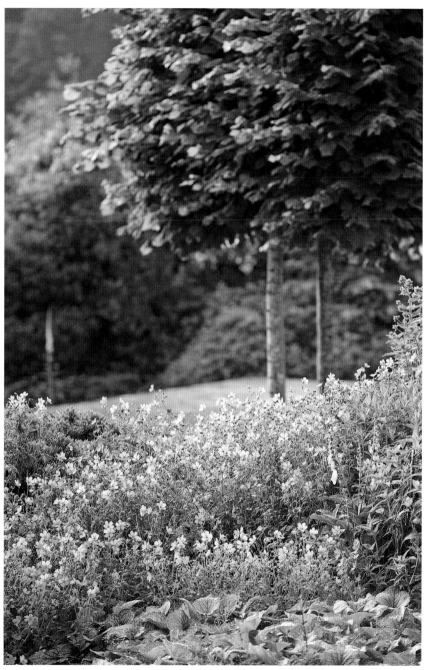

FAR LEFT A colour-themed mix of *Baptisia australis*, *Papaver orientale* 'Royal Wedding'. *Allium christophii* and *Viola* 'Eastgrove Blue Scented'. TOP LEFT *Allium christophii* and *Agrostemma githago* 'Milas Snow Queen'. BOTTOM LEFT *Geranium* 'Jolly Bee' and *Brunnera macrophylla* 'Marley's White' in the West Borders. ABOVE *Nepeta longipes* hort. and a delicate cross-polinated self-seeded poppy. RIGHT The row of pleached limes underplanted with hardy geraniums.

The view from beyond the ha-ha, which Sainsbury and Grimshaw built, towards the house, church, Tulip Folly and Woolbeding's majestic trees.

The house complete, the couple turned their attention to the garden. 'We wanted a quiet mood and the space divided into small, intimate areas,' writes Stewart Grimshaw. This would be somewhere to relax, a retreat from the stresses and strains of London. They called on the best garden designers. The American Lanning Roper, famous for his work on large country houses, started, naturally, with the bones of the garden. 'We soaked up his sage advice: whence the prevailing winds; the breadth of paths (unless for effect, always wide enough for two people); where to have drinks of an evening; how to plan a circuit to give purpose to our strolls...'

They then created one of the showpieces of the garden: long double borders to the west of the house. Lanning Roper set the theme to silver and grey, but the couple later peppered the scheme with blues and purples to add interest and lengthen the flowering season. The result is enchanting – delicate and utterly romantic. In May, a wisteria clothes the wall with its scented panicles, leading the way for a summer show of climbing roses and lavender-blue clematis. In the borders, gypsophila, salvias, roses and lavender interlace with white foxgloves, alliums, blue and purple irises, astrantias and angel's fishing rods (*Dierama*) to form hazy, impressionist pictures. A stone bench sits in the south-facing border, enveloping you in the scene. As elsewhere in the garden, no seats ever face each other: this is a garden to be enjoyed quietly and in solitude.

The estate's old walled garden proved the perfect canvas for an area of linked garden rooms. In the Well Garden, hostas, euphorbias, ferns, brunneras and plume poppies (*Macleaya microcarpa* 'Kelway's Coral Plume') blend in a symphony of many-shaded greens with barely a flower in sight.

The Herb Garden – a raised platform of brick and stone, with a sundial at its centre – features small beds edged with low box hedges, dotted with topiary balls and spirals. Its structure recalls the tidy gardens of Tudor times, but the planting is much freer. Among more traditional herbs are echinaceas, evening primroses, alliums, achilleas, clary sages in varying shades of pink, purple and white, and the lacy umbels of *Ammi majus*.

Design reaches a height of sophistication in the Fountain Garden. The four beds, centred round an Italian fountain of a young man with dolphins, are so dense with plants you will want to pore over them at length, reaching closer to inspect individual blooms then stepping back to take in the exquisite flower combinations. Your eye is taken imperceptibly round the colour wheel, from pale purple (*Linaria anticaria* 'Antique Silver') to apricot (*Agastache aurantiaca* 'Apricot Sprite'), yellow (*Crocosmia* x *crocosmiiflora* 'Coleton Fishacre'), burnt orange (*Eremurus* x *isabellinus* 'Cleopatra') and burgundy (*Nicotiana langsdorffii* 'Hot Chocolate'). The choice and range of flowers is as charming as it is learned. As garden writer Mary Keen neatly observed: 'At Woolbeding the planting

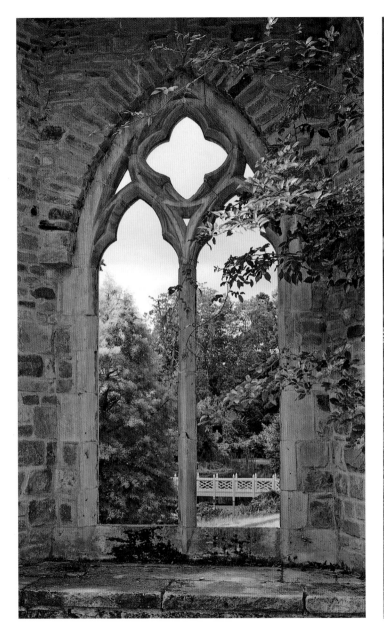

A mock ruined abbey marks the start of the Long Walk; its lancet window frames the view towards the Chinese Bridge.

With wild grasses and cow parsley in the foreground and the Chinese Bridge in the background, this view, like many others at Woolbeding, is a perfect blend of nature and design.

The great river god overlooks his kingdom from his grotto in the Long Walk; the planting is naturalistic but immaculately maintained.

succeeds in pleasing the romantic as well as the plant buff.' Nowhere is this truer than in the Fountain Garden.

Having finished the walled garden project, the couple focused on transforming the area at the very end of the garden, which takes you past the croquet lawn and paddock. They enlisted the help of gardening duo Isabel and Julian Bannerman, famous for their work at Highgrove, Prince Charles's private garden in Gloucestershire. 'After a year in the planning and two in the execution – the Bannermans' limitless enthusiasm tempered by

Sainsbury's natural restraint – the result was a pleasure ground with a ruined abbey, hermit's hut, Chinese bridge, rustic walk, grotto with river god, Gothick summerhouse, waterfall, rills, stumpery and bubbling source, roughly in that sequence,' writes Stewart.

The Long Walk – as it was christened – is a place of unexpected whimsy, yet it feels authentic and almost effortless. It could easily have been created in the eighteenth or nineteenth century. Everything works: the scale, the composition, the atmosphere. Being perfectionists, the Bannermans even worried about making

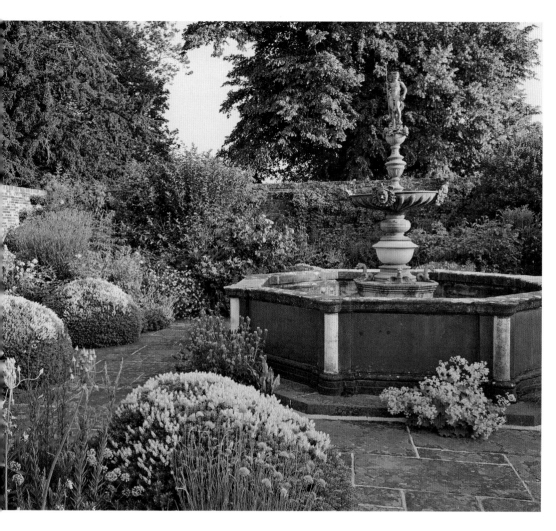

ABOVE *Eryngium bourgatii* 'Picos Blue' in the West Borders. LEFT A romantic mix of candy pink roses, flowering *Hebe rakaiensis*, pastel *Allium schoenoprasum* and *Campanula lactiflora* 'Loddon Anna' in the Fountain Garden. FAR LEFT The Herb Garden in spring, with *Nepeta* 'Six Hills Giant' and *Salvia officinalis* 'Purpurascens' in the foreground.

sure there was a logical source to the water. They devised the entire plan around the idea that the source should be situated at the culmination of your journey. As you walk past the features and follies, you eventually enter a nether world of dark evergreens. Then, in a small clearing there appears, as if by magic, a giant tufa monolith, from which bubble the waters of the Rother. It is a deeply satisfying ending to an engrossing journey.

Throughout the 26-acre garden, the attention to detail, scale, composition and planting are exceptional. Everything speaks of perfection and of the long-term. It took the couple 30 years to grow a great carpet of campanulas under an Oriental plane tree, but as Grimshaw points out: 'Some things in gardening cannot be hurried.' With a view to the future, the couple created meadows, planted many trees and built memorials to fallen ones. On a hill in the distance, Grimshaw erected a classical folly in Sainsbury's memory: his spirit will look over this loveliest of gardens for many years to come.

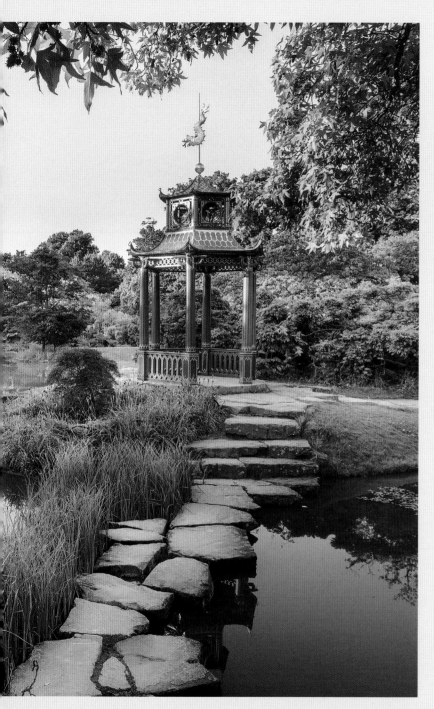

CONTEMPLATIVE SPACES

Some of the best gardens offer a tranquil, almost meditative environment. Greens, in the form of topiary, lawn or foliage; pastel shades such as pale pinks and lavender blues; the mellow tones of autumn – each of these can create a soothing visual envelope. Add to the scene ruins, sculptures, temples or water features and a sense of permanence is created, as if it has looked the same for centuries.

This timeless and reflective quality is a key ingredient in the Zen or Japanese garden. It is an intensely spiritual place and a medium for meditation. Water symbolises life, rocks signify longevity and bridges are passageways between two worlds: the physical and the spiritual. Sinuous paths and stepping stones slow your step, helping you focus on the present and the beauty in front of you; the ultimate aim being to reach a state of harmony with nature.

At the turn of the twentieth century, a craze for all things Japanese took hold of Britain and other European countries. Artists emulated the effects of Japanese prints, interiors featured folding screens and lacquered furniture, and garden makers created their own Japan-inspired plots. In 1910, Henrietta Bankes designed a secluded Japanese Garden at her home at Kingston Lacy, Dorset. She ordered specimens direct from Tokyo, including bamboos, cherries and acers. Stone from the family's Purbeck

LEFT The Japanese-inspired Water Garden at Cliveden, Buckinghamshire. Commissioned by William Astor in the 1980s, it was designed as a space for both reflection and entertainment. FAR LEFT, TOP Away from the main garden highlights, the peaceful summerhouse at Nymans in Sussex has views across the wildflower meadow and towards the wider landscape. FAR LEFT, BOTTOM The Amphitheatre at Claremont Landscape Garden in Surrey offers the perfect setting for quiet contemplation.

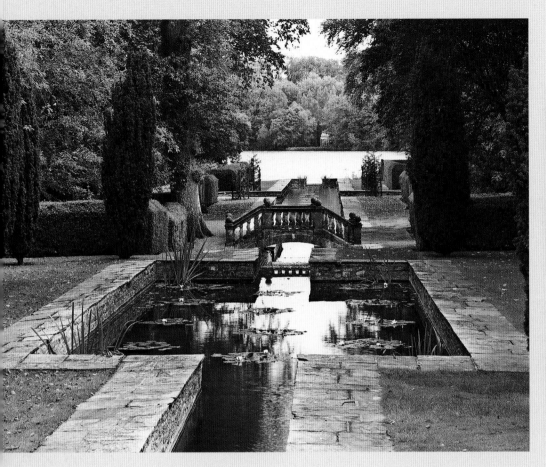

quarries created a miniature Japanese landscape. At the heart of this display, she built a traditional tea garden with gravel paths, a pond and tea-house, where she would stroll and take tea, dressed in a kimono. Similar gardens can be seen at Cliveden in Buckinghamshire, Tatton Park in Cheshire and Biddulph Grange in Staffordshire.

Many other types of garden have this capacity to quieten the mind and feed the soul: picture-perfect landscape gardens of the eighteenth century, subdued memorial gardens and water gardens – especially those where the water is still and reflective. Even a simple seat with a view can create uplifting, sometimes hypnotic, effects. As the essayist, poet and politician Joseph Addison once wrote: 'A beautiful prospect delights the soul.' The intimate landscape at Prior Park near Bath has this quality. On a winter's day, you may have this peaceful wooded valley all to yourself. It may not be a secret garden, but the feeling of secrecy is certainly there.

LEFT: The Peto Garden at Buscot Park, Oxfordshire, combines water features and tall evergreens to create a dramatic yet meditative atmosphere.

ABOVE A lantern in the Japanese Garden at Kingston Lacy, Dorset. Created by Henrietta Bankes in the early twentieth cenatury, she would take tea in this garden dressed in a kimono.

Statuary is used to great effect at Anglesey Abbey in Cambridgeshire. This is one of twelve busts of Roman emperors in the garden's Emperor's Walk.

Winter gardens too possess a serene quietness. On a frosty day, the garden is frozen in time, as if immutable. A stroll along the Winter Walk at Anglesey Abbey in Cambridgeshire can induce a meditative state. So too can this garden's majestic avenues punctuated with antique statuary and other eye-catchers.

Of all the colour schemes, white gardens are one of the most relaxing. As she dreamt of creating her white garden at Sissinghurst, Vita Sackville-West wrote: 'I cannot help hoping that the grey ghostly barn owl will sweep silently across a pale garden, next summer, in the twilight.' A garden at dusk: what could be more enchanting?

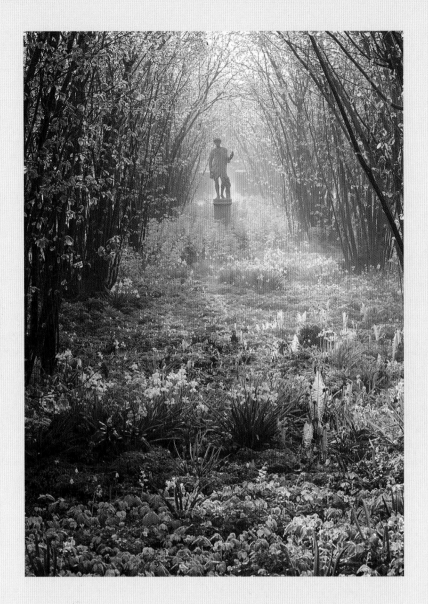

ABOVE The sculpture of Dionysus in the Nuttery at Sissinghurst, Kent, draws the eye into this visually soothing tunnel of Kentish cobnuts, underplanted with shuttlecock ferns, white bluebells, wood anemones and oxslips.

RIGHT Nymph statues and yew hedging covered in a veil of frost at Chirk Castle, Wrexham, during winter.

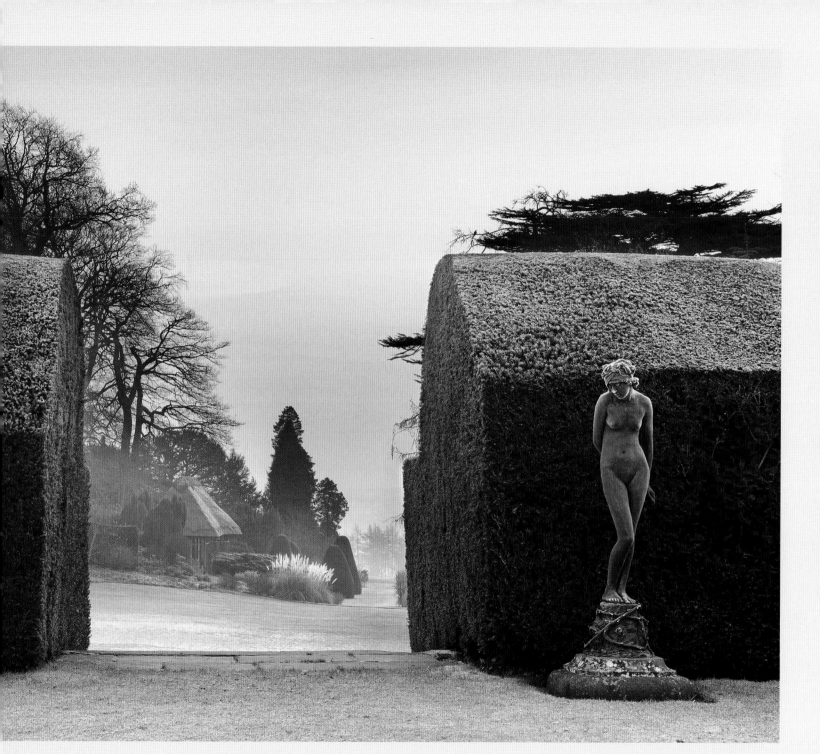

ABOVE A round pond planted with water lilies and backed by a wall of clipped yew and a solitary sculpture create a subdued atmosphere in the Pool Garden at Knightshayes, Devon.

RIGHT The Fernery at Greenway, Agatha Christie's home in Devon, is an enclosed garden of water-worn limestone with a central pool and fountain.

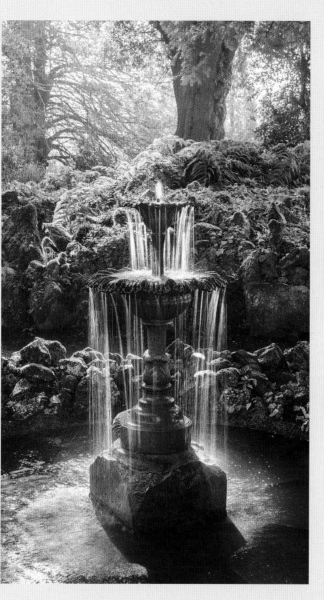

TOP RIGHT Tir N'an Og at Mount Stewart, County Down – a family burial ground built by Lord and Lady Londonderry in the 1920s.

RIGHT Looking towards the house at Chartwell, Kent, from the hill above; Winston Churchill, who lived here from 1922 until his death in 1965 and created many of the garden's features, bought the house for its views.

More
Secret
Gardens

STONEACRE, KENT

In the 1920s Stoneacre became the home of writer and designer Aymer Vallance. Almost a ruin, this fifteenth-century yeoman's house represented an irresistible opportunity for its new owner. Aymer Vallance was a disciple of William Morris – he even wrote two books on his hero. Like Morris, he loved medieval architecture and believed in sympathetic restoration of old buildings, using local materials and traditional crafts. At Stoneacre, he put his passion into practice, adding panelling, fireplaces and windows from houses of a similar age and decorating the interiors with antique furniture, Arts and Crafts fabrics and delicate stained glass created to his own designs.

While the garden today is very much the creation of the tenants who have lived here over the years, it sings with a relaxed informality and naturalism that chimes with the Arts and Crafts ethos of the building. Close to the house are areas of lawn edged with narrow paths and borders. Topiary cones and pyramids add structure and a hint of order to the fairly loose planting within the beds, where self-seeders are encouraged. At the back of the house, the courtyard garden is Stoneacre's outdoor room: a place to sit and relax amongst a sea of purple alliums in early summer. From this relative formality, the garden opens onto wilders areas. The orchard, home to native apple trees, features a little summerhouse by Aymer Vallance. On a good day it offers wide views of the North Downs. Further afield, a sea of wild daffodils drowns the meadow in spring, while in summer a wave of white cow parsley takes over.

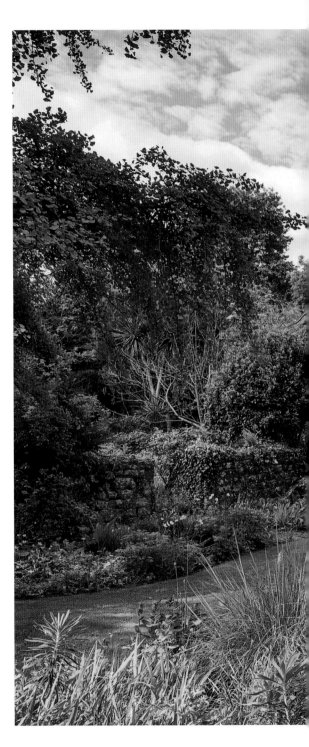

PREVIOUS PAGE Informal and welcoming, the front garden at Stoneacre sets the tone for the whole property.

RIGHT Stoneacre's front garden in early spring. Self-seeded Welsh poppies add bright yellow splashes to the borders edging the main path.

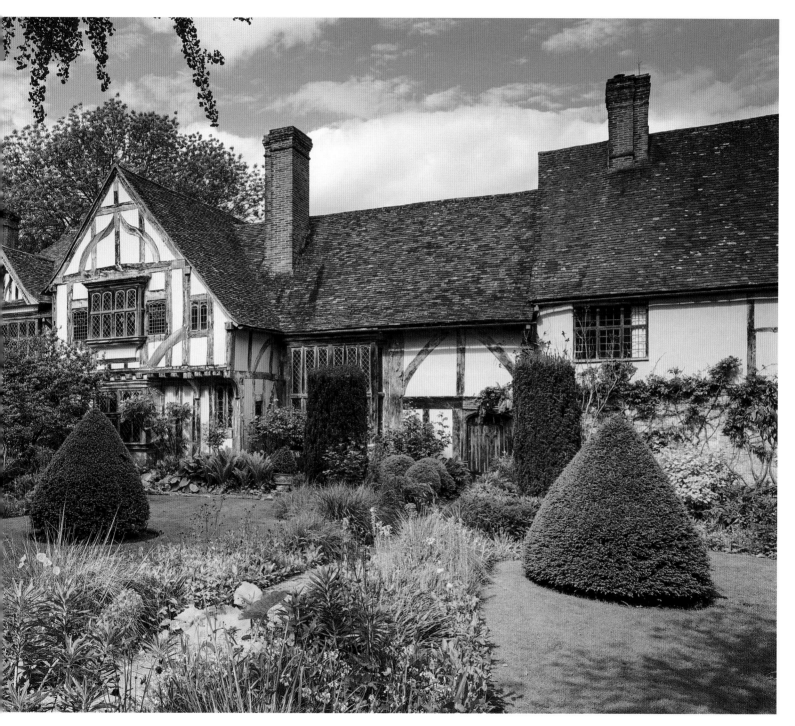

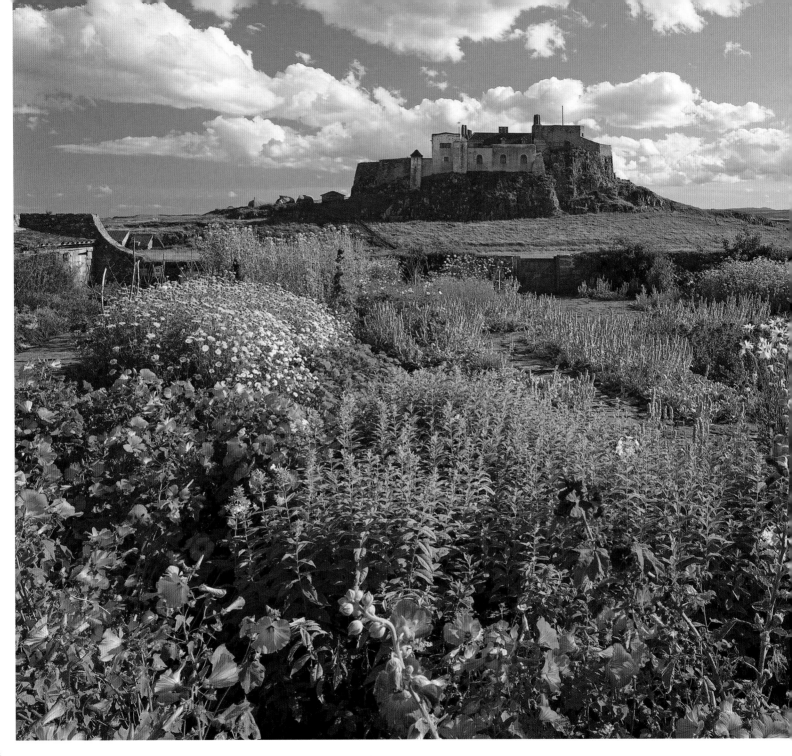

LINDISFARNE CASTLE, NORTHUMBERLAND

Set against the striking outline of Lindisfarne Castle is Gertrude Jekyll's most unexpected creation. This small colourful walled garden looks as though it has magically landed amongst a harsh landscape of grey stone and dramatic skies.

In the early twentieth century, the derelict castle was remodelled by Jekyll's friend and collaborator, Edwin Lutyens. Remote and romantic, it espoused many of the qualities that its owner, Edward Hudson, sought to promote in *Country Life*, the magazine he founded in 1897. It was only natural that Jekyll, who had designed Hudson's garden at The Deanery in Berkshire, should create this one too.

In 1906, Jekyll, eccentric and in her sixties, made the long journey by train then rowing boat to Holy Island with Lutyens, a raven called Black Jack and a large bag of peppermint bull's eyes. Once there, she studied and sketched the local wildflowers, finding inspiration for her planting amongst the island's rocky landscape.

Her design is simple: a central sundial surrounded by interlocking flower beds and wide paths created by Lutyens. She devised borders that would flower in summer, when Hudson was staying in the castle: roses on one side, espaliered fruit trees, vegetables and herbs on the other, and cottage garden favourites such as marigolds, sweet peas and hollyhocks in the central beds. Today the garden has been restored in the spirit of Jekyll, with the added bonus of a longer flowering season. Spring bulbs and autumn-flowering plants such as chrysanthemums and gladioli extend this most surprising of sights.

Lindisfarne Castle is Gertrude Jekyll's most remote garden. As with many of her creations, she collaborated with Edwin Lutyens, who remodelled the castle in the early twentieth century.

GREAT CHALFIELD MANOR, WILTSHIRE

Here in deepest Wiltshire is a place that time has forgotten. Honey-coloured medieval buildings – manor, barn and church – create a picturesque ensemble within natural surroundings of undeniable charm. Between 1905 and 1911, local businessman Robert Fuller set about restoring Great Chalfield Manor under the guidance of noted architect Harold Brakspear. At the same time he enlisted the help of garden designer Alfred Parsons.

Evocative of a romanticised medieval past, Parsons's design complements the house perfectly. Predictably, roses are a key ingredient. Soft pink polyantha *Rosa* 'Nathalie Nypels' grace the island beds in the paved courtyard, where climbing roses are left to clamber over pillars and walls. In the orchard rambling roses deck the trees in midsummer.

Parsons added dry-stone walls to create terraces linked by flagstone paths, further confirming the connection between house and garden. Respectful of both the past and nature, he kept some of the ancient trees and planted native flowers. This tradition is continued today in the orchard, where wildflowers and bulbs are a spring highlight. Pastel-coloured herbaceous borders add to the romance, while large expanses of lawn are punctuated by dramatic yew 'houses', so big you can walk into them. In true Arts and Crafts style, the garden gets wilder the further you get from the house. Beyond the fishpond a timeless picture opens up: the age-old house shelters in a grassy meadow of cow parsley, rose bushes and old apple trees, quietly reflected in the water.

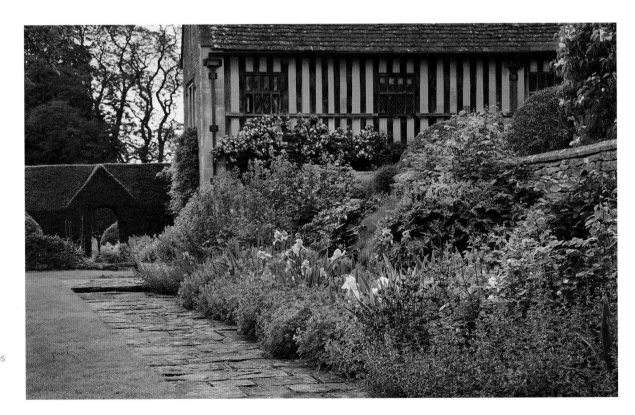

A romantic blue and white border with hardy geraniums, catmint and irises in the garden at Great Chalfield Manor. The half-timbered wing was rebuilt in 1910.

St Michael's Mount, Cornwall

St Michael's Mount is rightly known as 'the jewel in Cornwall's crown'. Dramatically picturesque and steeped in history, the castle and church proudly top a rocky island in Mount's Bay, luring photographers and seekers of scenic drama.

The sub-tropical gardens are a miracle. Perched on steep terraces and under constant attack from gales and sea spray, they somehow flourish. Tender and exotic plants cling defiantly to the granite cliff face. The Gulf Stream is a tempering influence, ensuring that very few frosts threaten the sculptural agaves, aloes, aeoniums, yuccas, echeverias and other succulents nestling within the rocks and stone walls. Rosemary, lavender, coronilla and mesembryanthemum tumble down terraces, where artemisia, cineraria, helichrysum and pennisetum echo the changing shades and shapes of the sea. Bright touches are provided by kniphofias, *Amaryllis belladonna*, *Leonotis leonurus* and nerines. Like Overbeck's, this is a garden that pushes the limits of what is possible. You have to see it to believe it.

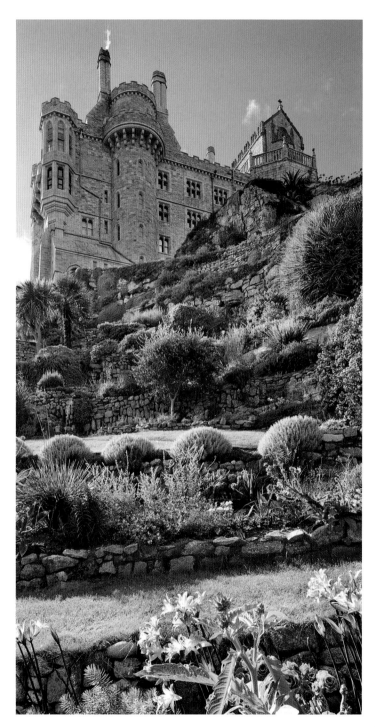

The famous castle and church at St Michael's Mount crown the steeply terraced garden. Mediterranean plants such as artemisias rub shoulders with exotic and tender plants, such as the nerines in the foreground.

STAGSHAW GARDENS, CUMBRIA

On a steep hillside above the attractive Lake District town of Ambleside is a secluded garden of hillocks and dells. Narrow meandering paths take you past a stream and little waterfalls criss-crossed by wooden bridges, via a series of painterly views. 'Sheer perfection in woodland gardening' is how Stephen Lacey, author of *Gardens of the National Trust*, describes Stagshaw Gardens. Created by Cubby Acland, the National Trust's area agent for Cumbria between 1959 and 1979, this is a place of natural beauty heightened by an artist's eye and a plantsman's touch.

Acland opened views, created glades, thinned native trees and planted an astonishing collection of rhododendrons, azaleas, camellias and other unusual shrubs and trees. Subtle colour combinations – salmon pinks with whites and oranges in places, the palest of yellows with subtle lilacs in others – are complemented by elegant underplantings of wildflowers, ferns, heathers and woodland perennials. Undulations in level and changes in direction produce of an array of viewpoints. It takes patience and skill to create such a garden – and an equal amount to maintain it.

In spring, the oak and beech woodland at Stagshaw Gardens is the setting for mass flowerings of azaleas and rhododendrons.

WORDSWORTH HOUSE AND GARDEN, CUMBRIA

It was in this elegant Georgian townhouse that William Wordsworth was born in 1770. And it was here that he spent many childhood hours exploring the small garden, developing his love of the natural world that would inspire so much of his writing.

Today the restored walled garden in the heart of Cockermouth is designed to look as it would have done when the Wordsworth family lived here: abundantly productive yet full of beauty. Within its formal layout of long and rectangular beds are cottage garden flowers, herbs, fruit trees and vegetables, many of which were grown in the late eighteenth century. Near the walls are espaliered apples and pears, as well as old varieties of plum and greengage. The central plot features productive beds of peas, runner beans, radishes and other heritage vegetables mixed with companion plantings of herbs and flowers, including marigolds and borage. Physic beds are filled with medicinal plants, such as hyssop, bistort, tansy and feverfew, while at each end of the garden are flower borders: one for cut flowers, the other brimming with old moss and Gallica roses and waves of catmint. A raised terrace designed for promenading runs parallel to the River Derwent; here, more roses scramble enthusiastically over the walls and honeysuckle scents the air.

Lavender, rosemary and fennel in the walled garden at Wordsworth House. Many of the walls are home to fruit trees which would have been grown in the late eighteenth century when Wordsworth lived here as a child.

LLANERCHAERON, CEREDIGION

Llanerchaeron is a rare survival. Remarkably unaltered for over 200 years, it has recently been restored as a working farm. This traditional rural estate comprises an elegant Georgian villa, extensive farm buildings and servants' quarters, and two walled gardens.

Designed in 1795 by John Nash, before his rise to fame as the architect of Buckingham Palace and the Royal Pavilion at Brighton, the quietly neoclassical house is a gem. The surrounding parkland, with its framed views, clumps of trees and lake, shows the influence and possible hand of Humphry Repton, the most popular garden designer of the time and collaborator of Nash. Today sheep and Welsh black cattle graze the meadows, adding to the peaceful pastoral setting, but it is when you enter the walled gardens that the hushed atmosphere is most strongly felt.

Abundance is the order of the day here. Ancient fruit trees – some over 200 years old – stand majestic amongst recently planted historic varieties, including over 50 different types of apple. Plums and gages cover the walls and yet more apples grow as cordons. The large herb garden, arranged into 25 rectangular beds, is an impressive mix of culinary and medicinal plants. Elsewhere, row upon row of root vegetables, legumes, cabbages, asparagus, rhubarb and bush fruits are complemented by cottage-garden favourites such as sweetpeas, cosmos, dahlias, sunflowers and crocosmias. The old cold frames, Victorian greenhouse and remains of fire pits once used to heat the walls are yet more reminders of days gone by. This delightful estate makes you feel as though you've stepped back in time.

Dahlias and cosmos flowering in August in one of the walled gardens at Llanerchaeron.

BIBLIOGRAPHY

Allan, Mary, *The Women of Plas yn Rhiw* (Llygad Gwalch Cyf, 2005)

Arnim, Elizabeth von and Elizabeth Jane Howard, *Elizabeth and her German Garden* (Virago, 2006, new edition)

Attlee, Helena, *The Gardens of Wales* (Frances Lincoln, 2009)

Bennett, Jackie, *The Writer's Garden* (Frances Lincoln, 2014)

Bisgrove, Richard, *The Gardens of Gertrude Jekyll* (Frances Lincoln, 1992)

Brown, Jane, *The Pursuit of Paradise: A Social History of Gardens and Gardening* (HarperCollins, 1999)

Buchan, Ursula, *The English Garden* (Frances Lincoln, 2006)

Campbell, Susan, *Walled Kitchen Gardens* (Shire Books, 2006)

Campbell, Susan, *A History of Kitchen Gardening* (Frances Lincoln, 2005)

Denyer, Susan, *At Home with Beatrix Potter* (Frances Lincoln, 2009)

Fish, Margery, *We Made a Garden* (Batsford, 2016)

Gammack, Helene, *Kitchen Garden Estate* (National Trust, 2012)

Grimshaw, Stewart, *The Loveliest Valley: A Garden in Sussex* (Damiani, 2016)

Gristwood, Sarah, *The Story of Beatrix Potter* (National Trust, 2016)

Hobhouse, Penelope, *On Gardening* (Frances Lincoln, 2001)

Howard, Jonathan, *A Thousand Fancies: The Collection of Charles Wade of Snowshill Manor* (The History Press, 2016)

Keating, Honora, *Plas yn Rhiw* (National Trust, 1982)

Lacey, Stephen, *Gardens of the National Trust* (National Trust, 2016)

Lear, Linda, *Beatrix Potter: The Extraordinary Life of a Victorian Genius* (Penguin, 2008)

Lee, Hermione, *Virginia Woolf* (Vintage, 1997)

Masset, Claire, *Orchards* (Shire Books, 2012)

Masset, Claire, *Beatrix Potter's Hill Top* (National Trust, 2016)

Rutherford, Sarah, *The Arts and Crafts Garden* (Shire Books, 2013)

Taylor, Patrick (ed.), *The Oxford Companion to the Garden* (Oxford University Press, 2006)

Way, Twigs, *Gertrude Jekyll* (Shire Books, 2012)

Zoob, Caroline, *Virginia Woolf's Garden: The Story of the Garden at Monk's House* (Frances Lincoln, 2013)

Index

References to illustrations are in *italics*.

PICTURE CREDITS

ACKNOWLEDGEMENTS

Huge thanks are due to the following brilliant gardeners and experts without whom this book could not have been written: Mike Calnan, Victoria Cody, Andrew Darragh, Jessica Evans, Chloe Ferrier, Paul Gallivan, Stewart Grimshaw, Llifon Jones, Allison Napier, Sara Nichols, Robert Owen, Allison Pritchard, Catrina Saunders, David Scott, Pete Tasker and Richard Wheeler. Thanks also to the creative and editorial talents of Katie Bond, Andy Butler, Amy Feldman, Chris Lacey, Lucy Smith and Peter Taylor. Above all I am most grateful for the unflagging support, enthusiasm and suggestions from my mum, Sarah.